Julie

Many Blessi

_Jmle Bleu_

8-7-08

# Carol &
# EDNA

Pirate 25

# Carol&
# EDNA

*As Told by Their Family, Friends, and Neighbors*

*by*

## LINDA S. BOWLBY, M.D.

*Psychiatrist*

Red Earth
PUBLISHING, INC.
*Oklahoma City, Oklahoma*

## OTHER TITLES AVAILABLE BY THE AUTHOR

### Adult Nonfiction:

*Red Earth Woman*

*Red Earth Wisdom*

*RenaissanceWoman*

### Red Earth Children's Stories:

*Future Hope*

*How Amazon Got Her Name*

*Is That So*

*Nasaria's Family*

*Nentuk's New Family*

*The Rock Garden*

**Red Earth**
PUBLISHING, INC.

Copyright 2008 by Red Earth Publishing, Inc./www.redearthpublish.com

Printed in the United States of America.

ISBN 10: 0-9779993-3-5

ISBN 13: 978-0-9779993-3-0

Library of Congress Catalog Number: 2007943124

Cover and contents designed by Sandi Welch/www.2WDesignGroup.com

# Contents

Some names have been changed to protect
the privacy of those concerned.

Many of the neighbors, friends, and family
members provide what appears to be conflicting
information regarding the various individuals
under discussion. Such discrepancies are normal
given that every individual's perception of another
carries personal filters. Differing views of the
same person may also reflect various phases and
time sequences of the described individual's life.

# Dedication

*To the spirits of Carol and Edna,*
*to their historians,*
*and to all who dare to be truly themselves.*

# *Preface*

CAROL AND EDNA IS A WORK based on the lives of two women who died in 2005 at the ages of 75 and 92, respectively. Carol and Edna occupied the same residence for 45 years in a Catholic, blue-collar neighborhood near downtown Oklahoma City. To use a tried-and-true country descriptor, Carol and Edna were a couple of pistols and, to cap it off, the women's families and long-time neighbors and friends were of similar ilk. However, Carol and Edna lived with a secret that markedly impacted their lives.

I came to know Carol and Edna via a circuitous route. On the morning of August 14, 2005, I was talking on the phone to my friend, Jane, who lives in Wisconsin. I told Jane that a small, white-frame house surrounded by blooming flowers had been coming to my inner vision for the last six months. I related that each time the house came to my mind's eye, I thought, "If I sell this house, I'd like to live in a house like that." The house had begun to come more frequently to my mind, and I continued to wistfully gaze upon it. I described to Jane that the house was much simpler and smaller than the home

I then occupied, which contained a portion dedicated to my psychiatric practice. Prior to this time, I had internally made the assumption that I needed to live in that residence until I stopped seeing patients, and that end was nowhere in sight. I shared with Jane that in my vision the house was very small, like a cottage, and appeared to contain only two bedrooms. I sighed and said, "Well, if that house is to be mine, God will show me how to fit into it." After my sharing, Jane remarked, "The house will find you."

Later that afternoon, I owned to myself that I had known for some time the area of town in which the house was located. Within a few minutes, I was compelled to drive there and see if this house was waiting for me. After driving to the location, within fifteen minutes, I found a white-frame house with a "For Sale By Owner" sign posted in the front yard. However, I puzzled over the fact that the house seemed taller than the house of my vision and there were no flowers. But I shrugged and figured God just meant for me to plant them.

I promptly called the phone number listed, and the owner, Bob, arrived within ten minutes. Bob related that the house was built in the 1920s and that he was just completing its total renovation, which included new electric wiring, plumbing, heating and air-conditioning units, kitchen, bathrooms, windows, and doors. Bob said that originally the house had only two bedrooms and one bathroom. However, in the renovation, Bob had built a staircase to the attic and converted its space

into a master bedroom and bath, which was complete with walls conforming to the angles of the eaves. This attic room reminded me of my Grandmother Ollie's attic bedroom where I had spent the most blissful days of my childhood.

The following day, I returned to the house and walked through each room, absorbing its quiet and tranquil presence. The house had 27 windows, and each room was luminescent and ideal for my plants, especially my orchids. For years, I had dreamed of purchasing, restoring, and living in my grandmother's white-frame, Arkansas home. This house, in an older section of Oklahoma City, felt like a smaller, restored version of my Grandmother Ollie's home.

Within six weeks, I had moved into the white-frame house, which I thought was the house of my vision. Since the house was half the size of my former residence, I pared down my possessions, selling a few but giving most of them away. "Simplify" was my motto.

In the following months, I moved my practice into an office building and sold the larger home. By October, my daughter, Sarah's, son, Carlos, was struggling in the Oklahoma City Public School's kindergarten program. From my neighbors, I was told of the excellence of the private Catholic elementary school located a block from my new home. Shortly thereafter, Sarah, her husband, Luz, I, and later Carlos's biological father toured the school. We all were greatly impressed by the school's standards and the probable quality of education

that Carlos, and later his two younger sisters, Leticia and Azriela, would receive there. Carlos enrolled in the school the following week, where he has since flourished under its tutelage.

Within a few months, Luz and Sarah rented a house located four blocks from Carlos's school and next door to Luz's parents. (Luz is one of eight children. He and his family emigrated from Mexico when Luz was eleven.) Sarah and Luz hoped to eventually buy a home within walking distance of Carlos's school.

For several months on my morning neighborhood walks, I kept my eyes open for a suitable home for my daughter and her family. During this time, I was coming to realize that I didn't use all of the space in my home and that it was larger than I really needed. Also, I was rapidly approaching 60, and I had decided that I didn't want to spend the next 30-to 40 years traversing stairs. For I fully intend to advance deeply into my golden years.

On a morning walk in May 2006, I spied a new "For Sale By Owner" sign on my street. Located a block from my home, the small, white-frame house appeared to be vacant and to contain two bedrooms. Obviously, the house was built about the same time as my home. With my curiosity peaked, I walked its perimeter. The external structure and that of its detached garage appeared to be in excellent condition. I surveyed the yard and observed many flowerbeds choked with weeds, tree

sprouts, and Bermuda grass but, in spite of the overgrowth and lack of care, a variety of brightly colored lilies were flaunting their plumage. Besides the flowers, I was drawn to the exquisite rocks that filled and surrounded the beds. I could readily see that the rocks were a treasure in and of themselves. For I have long resonated with rocks and am very sensitive to their energy, and these rocks were powerful.

Again, I phoned the person handling the property, Tamara, and was told that the house was still in probate, following the death of its owners. Tamara related that Edna, the oldest and healthiest, had died on June 5, 2005, and Carol, who had a heart condition and had lost part of a lung secondary to cancer and years of cigarette smoking, followed Edna within two months.

Tamara was able to show me the home's interior the following day and, as I suspected, it contained two bedrooms and was again half the size of my home. Its windows were covered by heavy, ancient drapes, and its walls and ceiling were lined by thin, dark paneling. The carpets were dark and old, and the kitchen and bathroom were dismal. In addition, the inside of the windows and the front and back doors were secured with black iron bars. In short, the interior was a claustrophobic's nightmare. As my home before it, I could see this house would require a full renovation, but I was uncertain if even that could sufficiently open the space. Disappointed, I told Tamara that I would have to think about it and thanked her for her time. As

I left, I just didn't think the house would work for me, because I can't abide closed-in spaces.

But the house kept calling my name, and each day my morning walks included a tour of its perimeter and yard. Finally, I intuitively knew this house was the house of my visions, and the home in which I resided was much better suited for Sarah and her family and was probably meant to be theirs all along. In buying the first white-frame house, my grandson found a new school, Sarah and her family moved into the neighborhood, and I was on hand when the little house was available for purchase. (Synchronously enough, Carol died on August 16, 2005, and I initially saw the two-story, white-frame house on August 14, 2005 and signed a purchase contract seven days later.)

Following my intuition, I scheduled an appointment for Wayne, the man who would do the renovations, to closely inspect the property. As Wayne and I walked through the house, we discussed possibilities for opening the rooms to the light and allowing them to breathe.

Tamara and I soon came to a purchase agreement. As we became acquainted, Tamara disclosed to me that she was the executor of Carol and Edna's estates. Tamara shared that for ten years she and her sister had rented a house across the street from Carol and Edna. Even after each of the sisters had purchased their own homes, they had maintained close friendships and frequent contact with Carol and Edna.

Even though the home continued to be embroiled in the probate court and the purchase could not be finalized, with Tamara's permission, I began my summer project—restitution of the flowerbeds. I called it my "dirt therapy."

For the summer, my walking was replaced by gardening. As the days and weeks passed, I spent hours upon hours on my hands and knees, elbows deep in dirt and Bermuda roots. As I wrestled the rocks and plants free from the choking roots, I felt like I was on a treasure hunt and was continually delighted by the beauty and energy of each newly unearthed rock, which was occasionally interspersed by a cache of a bulbs of unknown origins.

As I began to frequent the yard, long-time neighbors introduced themselves and, with smiling faces, told me of their memories of Carol and Edna. Early on, I was told that Carol was the gardener of the two and each time the two women took a trip, they returned with their car trunk full of rocks.

During my first days of gardening, I felt a disapproving presence, which I took to be Carol's spirit. This presence was uncertain if I was worthy of or capable to tend her flowerbeds. As I toiled, I would occasionally, silently hear myself being referred to as "girlie girl." I had never used such verbiage, and I didn't think the spirit meant it as a compliment. This phrase was often accompanied by disgruntled nudgings on my gardening technique. Inwardly, I told Carol to back off and quit giving me such a hard time. Besides, if she hadn't smoked

so many cigarettes all those years, she would still be tending her flowerbeds. That usually would shut her up. Sometimes, I would also be aware of Edna's presence. She seemed to be calmly observing.

As my work in the gardens progressed, it became evident to my observing spirits that I had the metal to warrant such a gift as their rocks and flowers. Having released its former disgruntlement, their presence became peaceful. One hot Sunday in the middle of June, after many hours on all fours, I again sensed Carol and Edna's presence. As they lingered, it came to my consciousness that they wanted me to write their story. Since these two women already intrigued me, I welcomed their request and felt privileged with their trust and the opportunity to explore their lives.

As neighbors, friends, and family members began to tell me of their memories of Carol and Edna, each storyteller gave another view of the lives of these two women. In doing so, the storytellers also opened windows into their own lives and the times in which they lived.*

*All interviews were conducted during the summer and fall of 2006.

# Pure Gold

AS THE LIVES OF CAROL AND EDNA were told to me, the tellers of their story granted me the privilege of viewing their own rich and colorful lives. In so doing, this book has become far more than a story of two women, but also a story of those who knew and loved them.

During this writing process and between interviews of various octogenarians, I had the occasion to hear a television commentary on an upcoming program to be aired on the Public Broadcasting Station. The commentator was bemoaning the needs of our expanding "elderly" population, who had lived "beyond their productive years." He went on to say that the aging "Baby Boomer" population, whose first members were born in 1946, would place a future burden on the younger, middle-income population.

First, I was incensed, then amused. Our society too often overlooks or negates our older citizens. As I met with and garnered the wisdom and history of the various contributors of this book, most of whom were in their 60s, 70s, and 80s, I was delighted with their wit, insight, and colorful language, and I

was deeply grateful for the living wealth of history from which they spoke.

Also, during this writing, I traversed the passage of my 60th year, and I look forward to these golden years ahead of me, which I hope will be suffused with the light of my living and the wisdom gathered from my time on the planet.

Regarding our aging population, I sense that most "Baby Boomers" will be more productive through their remaining years than the current "younger generation" can possibly conceive.

My champion and role model in such endeavors is Grandma Moses, who began painting when she was 76, because she could no longer hold a needle to embroider, but she could hold a brush. [1]

Like so many of the people that I interviewed, Grandma Moses was described as a "lively women with … a quick wit." In her last years she was said to be as "cheerful as a cricket" and to be "keenly observant of all that went on around her." [2]

The very observant storytellers of Carol and Edna found pleasure and humor in their everyday world and their friends and family. Likewise, for her subjects, Grandma Moses drew on her rural New York memories as a child, hired girl, and farmer's wife. With color and humor, she portrayed the simple farm activities of maple sugaring, soap-making, candle-making, haying, berrying, and the making of apple butter. [3]

In her advanced years, Grandma Moses was quoted as saying, "I look back on my life like a good day's work, it was

done and I feel satisfied with it. I was happy and contented, I knew nothing better and made the best out of what life offered. And life is what we make it, always has been, always will be." [4] This statement could easily have been made by most of the individuals found within these pages.

At her death in 1961 at the age of 101, Grandma Moses had produced more than 1,600 paintings and, until four months prior to her death, she continued to paint a little each day. [5]

The people found within these pages may not have painted any pictures or written any books, but the color and richness of their lives could have covered many canvasses and filled many pages, and we are all blessed by the gold of the accumulated years of their lives.

# Dot

DOT WAS BORN ON THE 15TH of October in 1917 and is Edna's only surviving sibling. When I arrived at a retirement village in which Dot has an apartment, she was expecting my visit. Dot's front door was open, and a glass door separated her living space from the main hallway. Moving slowly and with the support of a walker, the stooped, diminutive woman, wearing fluffy, pink house shoes, gestured me to come in; whereupon, she kindly greeted me. As I entered her living room, I took in its colorful array of knick-knacks and crocheted pillows, potholders, and table covers, and I felt as if I had just stepped into my grandmother's home.

I noticed Dot's gnarled, arthritic hands and commented on the lovely crocheted items.

Dot responded, "I do it to pass the time."

Before we could begin our conversation, Dot's telephone rang. It was her son, Bobby, whom she informed that she had company. "It is the lady that came to see me that bought Shorty's house." ("Shorty" is the family name for Edna.)

I subsequently learned that Bobby is 64 and lives in Blackwell, Oklahoma. Dot's conversation with Bobby was about his 8-year-old granddaughter, who had two types of cancer and was preparing to receive chemotherapy the following day.

As Dot concluded her phone call, she added, "A woman that lives here had cancer and lost all of her hair, and she wears a ball cap all the time."

Dot proudly told me that she is the mother of three sons, grandmother of nine, and great-grandmother of 19. She related that she had lived all of her life in or around the farming community of Yukon, which is located a few miles outside of Oklahoma City.

I soon learned that Dot married her first husband, Pete, in 1937, and, through most of their marriage and the rearing of their three children, Dot and her husband were in the "café business," until Pete died in 1971.

Dot described her husband as a very kind man, who always had sympathy for the underdog.

I asked about her job in the café.

"I did waitress and cashier, but when you own a place and someone doesn't show up, you do whatever they were supposed to do."

After Pete died in 1971, Dot lived in an apartment across the street from the café, which was located in downtown Yukon. She said, "I kept the café going until the equipment began to wear out, and it became too much for a woman by herself."

Dot sold the café before she married her second husband, Emil, in 1974. About Emil, Dot said, "When we married, he was 65 and had never been married." Knowing the habits of long-time bachelors, I asked her if she whipped him into shape. Dot smiled and nodded her head in the affirmative.

Dot went on to say, "Emil was a good guy, a farmer, and he worshipped the very ground I walked on." A few minutes later, she sadly commented, "Emil died in 1980."

Quickly doing the math, I asked Dot, "Has it been hard being single for 26 years?"

With downcast eyes, Dot replied, "Yes, very, very much."

Dot had lived alone in her six-room house until October 2005. She didn't think "this place" (her apartment) would ever be home to her, but "after I was in the hospital a few weeks ago, I was glad to get out, and it felt like I was coming home."

Regarding her other two sons, Dot told me that her son, Jackie, worked for the public service in Tulsa and died in 1965, at the age of 26, from electrocution. She added, "Jackie had two children by his wife, Gloria, and, even though Gloria remarried, she is more like a daughter to me than a daughter-in-law. She calls me all the time."

Her other son, Jimmy, was born in 1938 and now lives in Yukon. Dot described Jimmy as "real serious minded, and he takes care of me. He goes to get my groceries." Jimmy also occasionally brings Dot her favorite treat, a chocolate Frosty from Wendy's.

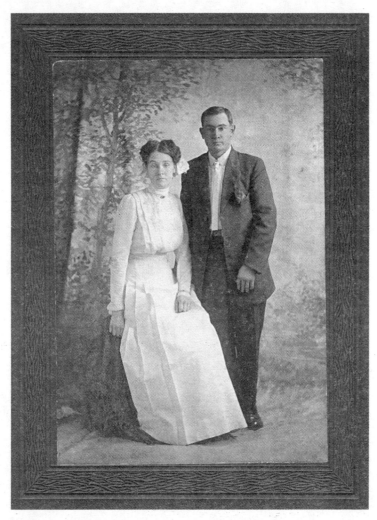

Dot and Edna's parents.

## THE FAMILY HISTORY

Dot began her family history by telling me she had a brother, Frank, who was born in August 1911 and died when he was "over 60." She had two sisters, Edna and Edna's twin, Ethel, who were born on February 10, 1913. Ethel died in April 2005, and Edna died two months later.

Dot related that their mother was born in 1895 and lived until she was 87. "My mother grew up southeast of Yukon, in the Mayview School District. She was fun-loving and a hard worker, and she had a hard life. My mother was raised by her

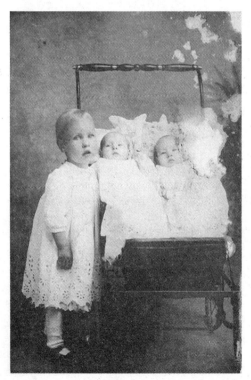

grandparents. My mother's parents divorced when she was young. My mother's father was solemn and straight-laced. He remarried and had five or six children by his second wife.

The twins, Edna and Ethel, and their older brother, Frank.

My mother's mother married a man that had a carnival, and they traveled all over the United States. My grandmother was quite worldly.

"I doubt if my mother ever finished grade school. She got married in 1910, when she was quite young. I don't know how my parents ever met. In those days, they only had a horse and buggy, and my dad grew up northwest of Piedmont, which was some distance away. After they married, dad built our house. My father had a dray service. He had a flat-bed wagon drawn by two black horses and, when anything was shipped in by train or street cars, he picked it up and delivered it to the businesses. We didn't have big trucks back then.

"Mom and Dad had quite a few arguments. They finally divorced when I was 10 or 11. Us kids lived with Mom."

I asked if her father had a drinking problem.

"No, but Dad was a drinker. He liked his own home brew and, when he drank, they had fights. After the divorce, my Dad stayed in town for awhile, then he went up north somewhere that they raise potatoes, may have been Idaho. He wasn't up north very long. Then he moved back to Oklahoma City, remarried, and worked for *The Daily Oklahoman* as a janitor. We didn't see him very often.

"On my father's side of the family, my grandfather was deaf and a grouchy old man, but I was a little-bitty girl when he died. My grandmother was the perfect example of a typical farm woman. I remember seeing a picture of her with a bonnet

Dot and Edna's mother.

on, feeding her chickens. My grandparents lived at Piedmont. Their only transportation was a horse and buggy, so we didn't see them very often."

About her mother, Dot said, "Mother did housework for other people. She took in washing and ironing. Once she took in an elderly man that had broken his leg and didn't have any place to go. There was also a small hospital in Yukon then, and she worked for a doctor as a midwife. Mother worked her fingers to the bone to put me through school. I was the only one in the family that graduated from high school.

"Mother put in a garden every year and would grow corn, tomatoes, peas, green beans, and onions, and we always had a potato patch. We would eat some of the onions young, and the others, mother would let get big and hang them in the barn to dry and use them in the winter for soups and things. In the garden, us kids would hoe, weed, and pick whatever needed picking. Then, we would help mother can. We didn't have freezers back then. Our refrigerators were ice boxes. A man in Yukon delivered ice to everybody in town, and he would say that he had the coldest ice in town." Dot chuckled, "Of course, he had the only ice in town.

"When I was the only one left at home, mother married Ollie. He was a good guy and good to us kids. He worked at the flour mill here in Yukon. He didn't have a drinking problem, but he sure liked his beer. Mother and Ollie stayed married until he passed in 1968. Until about four years before her death, mother

lived in the house that my father built. At the end, she got Alzheimer's and lived in a nursing home."

Dot went on to describe her siblings. "My brother, Frank, was a pretty friendly and gentle guy. He always worked at the flour mill. He married Vee, and they had three children. Vee was happy-go-lucky and was always out for a good time. She was a good person that worked at TG&Y for awhile after she and Frank divorced. After the flour mill shut down, Frank went to work as a janitor at a school in Oklahoma City. He remarried once, but it didn't last very long."

Of her two sisters, she said, "The twins quit school. It seems that they just didn't like it. Ethel got married when she was 15. Ethel's first husband, Ralph, was self-centered and out for himself. As I remember, of course I was just a little girl, they moved somewhere in Arizona or California, and Ralph left Ethel with that baby and without money. Somehow, Ethel got train fare and got back home, and my mother helped her raise her little boy, Archie. After Archie grew up, he got married and ran a grocery store in Yukon for awhile. Now, he lives in Oklahoma City."

Next, I asked Dot about Edna's nickname.

"Edna was always on the thin side and, since she was shorter than Ethel, we called her 'Shorty.' Ethel was always on the chunky side, and we called her 'Big Enough.' They called me 'Toots.' When they were young, the twins got along pretty good. Edna was happy-go-lucky and fun-loving, and she loved

to dance, play bingo and cards, and go fishing. Edna was more outgoing than Ethel. As they got older, they grew apart. Ethel married her second husband, Herbert. Herbert was a German farmer and a good man. After they married, Herbert and Ethel moved out on a farm, back in the sticks, and Ethel became kind of backwards. Ethel and Herbert did not have children together."

I asked about Edna's schooling and work life.

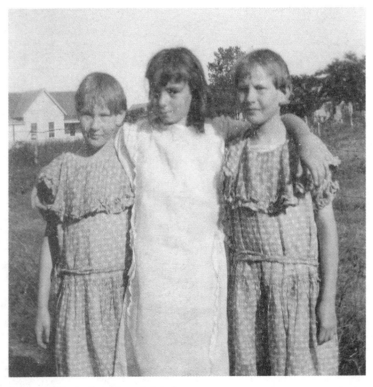

**Edna, a family friend, and Ethel.**

Ethel and Edna—Born Country.

"It seems like Edna graduated from grade school."

Later, as Dot and I sifted through family photographs and papers, we found Edna's grade school graduation certificate dated, May 10, 1928.

"After Edna quit school, she would go out in the spring and summer to chop cotton. [Chopping

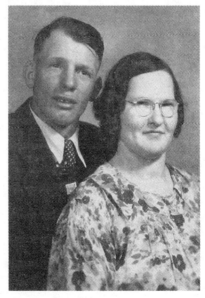

Herbert and Ethel.

**Edna—A Girl
With an Attitude.**

cotton is the cut-
ting of the weeds
from around the
cotton plant.] In
the fall, she would
pick cotton. After
that, Edna went
to California for
awhile.

"When she
came back, she
went to work for
Macklanburg-
Duncan. They

made metal things, like door frames, stools, and canes. [Dot
motioned to a cane behind her recliner.] Edna made that cane
for me. She worked for that company for 30 years. After she
retired, they lifted the retirement age, and she went back to
work for them for three more years. Edna liked her work real
well."

Among the photographs was one with Edna and a man. Dot
volunteered, "That is Joe, Edna's last boyfriend."

On describing Carol, Dot said, "She was kind
of sober. She worked at L.S. Bearing, where she

**Right: Edna— A
Woman of Many
Faces.**

**Edna—"Go West, Young Woman, Go West."**

got a piece of steel in one of her eyes and lost that eye. Carol was also in the Marine Corps at one time.

"I thought Carol was a great lady. She was real good to me, and she was good to Edna. Carol was very giving. Edna never came to my house that she didn't bring two to three packages of food or something that Carol thought

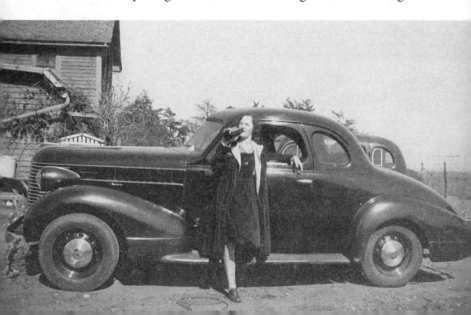

I might need. Shorty told me that Carol couldn't stand to see an animal go hungry and, at one time, she was feeding 30 cats and spending up to $50 a week on cat food.

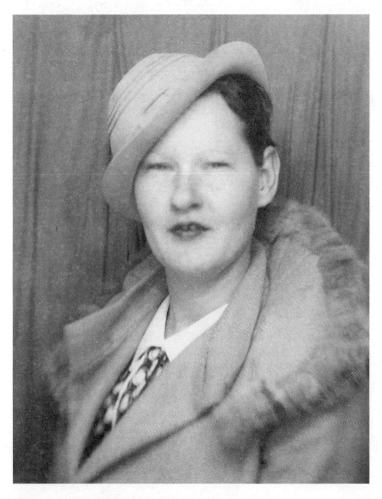

**Above: Edna—A Saucy Dame.**

**Left: Here's One for Prohibition.**

"Carol didn't come to my house very often.  Carol was very much a loner.  She didn't care too much for a lot of people."

I then asked Dot to describe Carol and Edna's relationship.

"They were very compatible.  They enjoyed each other when they traveled.  They went to Branson, Missouri, several times, and they would stop several places along the way and pick up rocks.  Carol and Edna never fought, and I never heard them talk bad about the other."

In the photographs, we found several with Edna holding a stringer of fish.  Dot commented, "Edna loved to fish.  My second husband and I bought a place on Lake Eufaula.  After Emil died, Edna went halves with me on the property. We moved off the old mobile home that was there, and Edna bought a new one and put it on my lot.  We would go down there almost every weekend and fish off the bank of a creek, river, or the

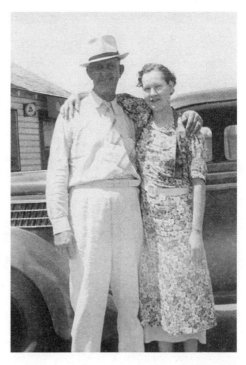

**Joe and Edna.**

lake. Carol never went with us. She was invited, but she just didn't want to go. When we fished, Edna and I used a rod and reel and sometimes cane poles, and we baited with minnows, worms, or sometimes stink bait. We caught mostly catfish and some crappie. Edna was the best at cleaning fish. If we cooked them, we fried them. I like them, but Edna didn't like to eat fish very much.

"At the lake, Edna and I got acquainted with the neighbors, and we would go play bingo with them. After the neighbors moved, Edna lost interest in going to the lake, and I didn't like going by myself. With the water and electric bills, taxes, lawn mowing, and winterizing, it became too much of a hassle, so we sold it."

Prior to Edna's death, she was in the hospital for two days. Dot said, "She had something that happens to the head—a stroke. It happened at night, and Carol called the ambulance. Edna never regained consciousness. I was there much of the two days before she died. Carol was there all the time. A lot of people kept coming in and out. People that I didn't even know. The day she died, the hospital called me at 6:30 in the morning. By the time I could get dressed and get someone to take me to the hospital, she was gone."

After Edna's death, Dot said, "Shorty didn't have a burial plot, so I said, 'Let's just bury her in my plot,' and Carol was OK with that. My first husband and I bought that plot, and we buried our son, Jackie, there, and I buried both my husbands there, and I am going to be buried between them.

"Carol took Edna's death pretty hard. She let me pick out everything for the funeral. My nephew, Archie, helped me, because he had just been through it with his mother in April.

"Shorty and I talked every day. After her death, Carol and I talked almost every day. We would talk about our neighbors or my crocheting. Carol would tell me about working in her yard and about her flowers and her rock gardens. She got 'Yard of the Month' one time. That made her real proud."

Dot went on to explain, "Carol's mother and father had lived in Chicago, and she still has a niece and nephew that live there. When Carol died that August, her niece came to Carol's wake. We met in the front yard of Edna's house. A group of neighbors sat in a circle and reminisced, and two or three girls played music and sang real good. Later, Tamara, her sister, two of the girls that sang, and I took Carol's ashes and scattered some on Edna's grave. Again, the girls sang their songs and played their music. Later, Tamara took the rest of Carol's ashes to Florida and scattered them on a beach."

As we concluded our talk that day, I felt grateful for my trip through history. As I left, Dot again reminded me of my grandmother, as she gifted me with a dish towel on which she had crocheted an attachment so that it could be hung on a refrigerator handle and a crocheted red-and-white University of Oklahoma cup warmer.

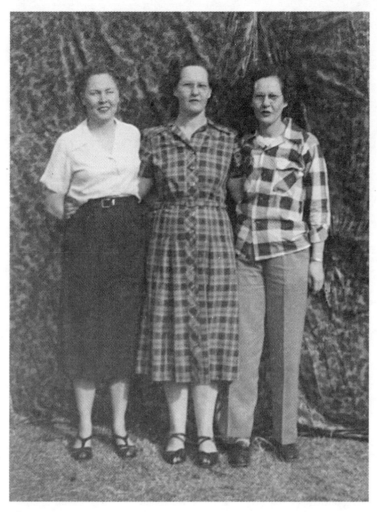

Dot, Ethel, and Edna.

# Archie and Lorene

I RANG THE DOORBELL of a lovely Oklahoma City home, and Archie opened the door, greeted me, and invited me into the formal living, where we were joined by his wife, Lorene.

Archie had been somewhat hesitant to grant me the interview because, in his professional life, he had several unpleasant experiences with reporters. During our phone conversations prior to my coming, I had assured Archie that he would be able to review and correct or delete anything in his interview with which he was not comfortable, and the publication of his interview would occur only after he had given written consent. Under these conditions, Archie agreed to my visit.

Initially reserved, Archie quickly warmed to me and spoke freely. Archie is a large, hulking man who walks with a cane, and I soon learned that he had had one hip and five knee replacements. Lorene is a lovely, demure lady, who I would never have guessed was born in 1926 and had just celebrated her 80th birthday.

Archie began, "We have three children, eight grandchildren, and two great-grandchildren. [Before I left that day, Lorene received a phone call from her granddaughter, who informed her grandmother that she was expecting their third great-grandchild.]

"Our family are good people. There is no fussing or fighting. Our family, that's our riches.

"Lorene and I got married just before her 19th birthday and my 17th birthday. Because we were so young, people said it would never last. They're dead and gone now, and we've been married 61 years."

Lorene inserted, "And we didn't have to get married."

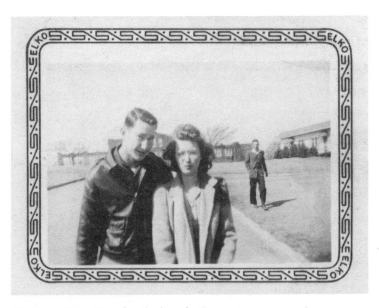

**Archie and Lorene taken before their marriage.**

Archie continued, "I had been living on my own for a while. I had a room above Dunn's grocery store in Yukon. I worked, went to school, and played football."

I asked Archie why he had left home at such a young age.

"Because my stepdad, Herbert, was real hard to get along with. I couldn't do nothing right. For no reason, he'd beat me. I left home when I was 13, and I never did go back. At first, I went to live with Aunt Dorothy (Dot). To pay for my rent, my job was to keep her three boys, who were ages three, five, and seven, when she and her husband, Uncle Pete, went out on Saturday night. Uncle Pete worked in the commissary at the Cimmarron Field Airport. He got me a job there. I lived with them quite awhile."

On the topic of Cimmarron Field, Archie said, "I met Lorene on Yukon's Main Street, while catching a bus to work. We both worked at Cimmarron Field. This girl introduced us. [Archie chuckled.] Lorene actually 'fell for me.' She slipped on the ice, and I caught her. Come to find out, her brother was my locker pal."

Lorene added, "I wouldn't talk to a boy unless I was introduced to him. I was raised pretty reserved."

Archie interjected, "I thought she was stuck-up." (Archie and Lorene met in January 1944, when he was 15 and she was 17.)

Next, Archie said, "In the summer of 1944, I worked on an ice truck in El Reno. The following school year, I worked from 7:00 at night to 5:00 in the morning at the Yukon Flour Mill.

Then, I'd go home to my apartment above the grocery store and sleep for a hour and a half. Then, I'd get up and go to school. After school, I had football practice. Then, I'd go home and sleep for another hour and a half. Then, I'd go to work at the mill. I did this from September 1944 until May 1945.

"When we dated on the weekends, we'd catch a streetcar to downtown Oklahoma City. Sometimes we would eat at 'Coney Island.' You could get three hot dogs for a quarter."

Lorene explained, "We did a lot of window shopping."

Archie added, "If we had the money, we'd go to the movies. For both of us, it cost about a dollar. But we did a lot of window shopping and walking. We got married in June of 1945, and we got a car in September of that year." Archie then informed me that the Japanese surrendered on August 14, 1945, and the peace treaty was signed on September 2.

I asked about their memories of World War II.

Archie responded, "My main memory was of so many people getting killed. We couldn't buy sugar or butter and, even after we bought our car, gas was still being rationed. After we were married, I got drafted, and I had to join the Reserves to keep from going, because by then Lorene was pregnant with our first boy, and she was having trouble with the pregnancy. Tony was born in April 1946.

"When we first got married, we lived on the 1200 block of Main Street, in Oklahoma City. We had bought our wedding

rings at a downtown jewelry store, and every two weeks we'd walk down to that store and pay them $5.00. That was big money back then.

"When our boys were four [Don] and five [Tony] years old, I was working for the Humpty Dumpty Grocery Store Chain, and I was drafted to go to Korea. I was there about a year. I went in as a private and came out as a permanent staff sergeant. Of course, I didn't make much money. I was so proud of Lorene. While I was gone, she took care of those boys, kept the house up and the boys fed, and that was quite an accomplishment."

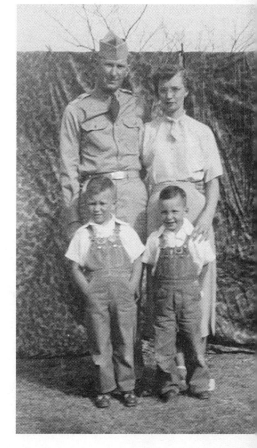

Lorene added, "When the check came at the first of month, our treat was to buy potato chips, pop, and bologna for sandwiches."

**Archie and Lorene; Tony and Don.**

Archie continued, "Before I left, we sold our car. Each month, we had a $48 house payment and an $8 fence payment, and Lorene never missed a payment. I got back in November of 1951. The following Monday, I went back to work for Humpty Dumpty.

"Before I left for Korea, all I had to do was hang my pants on the bedpost and Lorene would get pregnant. After I got home, we tried for a third child, but Lorene said that I must have left something over there, but finally our daughter, Susie, was born in November of 1953."

**Edna and Archie.**

Archie and Lorene married after she had graduated from high school and he had finished his sophomore year. Although Archie did not complete high school, he attended many educational conferences and had a very accomplished professional career. At his retirement, he was the vice president of an 80-store grocery chain.

## ARCHIE'S EXTENDED FAMILY

"My Aunt Shorty was very special to me," Archie said. "I grew up in her mother's house, with her and my mother. If I wanted something, like a piece of candy, and my mother said I couldn't have it, my Aunt Shorty or my grandmother would give it to me. But, Aunt Shorty would correct you, and she wasn't bashful about it. She could get real horsey with you. Aunt Shorty was real tough talking, but she was a marshmallow inside, and she was a good person with people. Everybody that worked with her liked her.

"When I was young, Shorty dated a police lieutenant named Joe. He was a big guy. He would let me touch his gun, but when I asked to hold it, he said, 'No, you're not big enough.'"

Archie returned to his favorite topic—his wife, Lorene. "Aunt Shorty always thought a lot of Lorene. Everybody loves Lorene. When Aunt Shorty was between jobs, she stayed with us and helped out while Lorene was pregnant with our oldest son. In fact, she was the one that took Lorene to the hospital."

I commented on my enjoyment of restoring Carol and Edna's flower gardens.

"Aunt Shorty was so proud when she bought that house. She bought my stepdad a saw, and he spent lots of hours working on it."

Archie changed topics. "I was named after my Grandpa Archie Hicks. He drove a dray wagon. He was an easy-going

and gentle man and a great person. He got killed changing a tire. Another car hit him.

"Lorene's dad was a blacksmith and was a lot like my grandpa. Lorene had the most wonderful parents you could ever want to meet. They were precious.

"My Grandma was kind of rough cut, yet she had a good heart. She cared for people, but she didn't want to let it be known too much. Her mother, Harper, was as rough as a cob. She ran a bar down in Corpus Christi."

Lorene emphasized Archie's point. "When Great-Grandma Harper came to visit, she was smoking, and she asked me if I smoked. I said, 'No, Archie wouldn't want me to smoke.' She said, 'No damn man's going to tell me what to do.'"

Archie went on to describe Ollie, his Grandmother Hicks's second husband. "Ollie had a pattern that didn't change. Monday through Friday, he got up at five o'clock every morning. He would drink three cups of coffee, roll four Prince Albert cigarettes, and smoke them. Then, he would walk to the Yukon mill. He'd come home about 5:30 every evening and eat his supper. Then, if it was decent, he would go outside and sit. Sometimes, I'd sit out with him. He wouldn't hardly say a word all week long. On Saturday morning, he'd get up, clean up, shave, and put on striped overalls. He wore striped overalls every day, but, on Saturday, he wore a better pair, his 'Sunday ones.' Then Ma [Archie's name for Grandma Hicks] would

Five Generations; Archie, Ethel, Archie's Great-Grandma Harper, Archie's Grandma Hicks, and Don.

drive him to the Yukon Bar. Ma would go in the bar with him. She wouldn't drink much, but Pa did. After he had a few beers, he was so friendly and had the nicest personality. He'd say, 'Oh, Archie, I love you.' That was the only time he told me that he loved me. Pa was a good man. He made a good living for Ma."

Archie next spoke of his mother's brother, Frank. "Uncle Frank was always close to us. After he and his wife divorced, he'd come to visit us. Almost every Sunday morning before church, he'd come to eat breakfast with Lorene and me. We once took him on a trip with us to Corpus Christi. On the way, we took him to the Cattleman's Café in Dallas. The waitresses wore short skirts, pistols, and cowgirl hats. It really made an impression on him. He'd say, 'I thought that girl was going to sit on my lap.' He just talked and talked about that trip. He'd tell anyone that would listen to him. Uncle Frank was a good man but, after him and Aunt Vee divorced, he was sad the rest of his life."

From his Uncle Frank, Archie turned to the subject of his father. "I'd always heard that my dad was a drunk and a SOB. In 1949, I went to see him one time. He was as nice as he could be. Uncle Frank had kept him informed, and he knew what sports my boys played. I always wished that I'd looked him up sooner." Archie was obviously very impressed and pleased that his father had followed his life through his Uncle Frank.

**Ollie and Grandma Hicks (Pa and Ma).**

Returning to his aunt, Archie said, "Aunt Shorty started fishing in the 1950s, and she got hooked on it. She'd fish all day long. Once, she came to our house for me to teach her how to tie hooks and weights. We'd wrap them around books of matches. Not too long after that, she went to Branson and went trout fishing. Another time, we had her, Carol, Dorothy, and my mother over for dinner. Aunt Shorty couldn't get over my mounted black bass that weighed a little over eight pounds when I caught it in Blue Stem Lake."

On being asked about Carol, Archie said, "We knew Carol, but not very well. I liked Carol. She was always nice and friendly to us. I was always interested in her gardening. She could grow the best-tasting tomatoes that I have ever eaten.

"Carol and Aunt Shorty were real close. They always had a lot of concern for each other. They treated each other with respect. They seemed happy and content, and they both seemed at peace."

❀ ❀ ❀

During the interview, both Lorene and Archie commented that they had lived a good life and that if they were to die, they were ready, but Archie added, "I don't want to go on the next bus."

For Lorene's 80th birthday, her daughter-in-law compiled an anthology of quotes from Lorene, which included the following:

I used to feel strongly about living my
life by the Golden Rule, and I still do.

I have no regrets.

If I had my life to live over,
I'd not change a thing.

The most precious things in the world to
me is my life with Archie and to see our
grandchildren grow up.

As I was leaving, Archie directed my attention to the large Christmas tree occupying a corner of the living room, even

**Archie and Lorene in Carol and Edna's living room.**

though it was the middle of summer, and said, "Every day is Christmas at our house.

"Lorene made every one of those decorations. Pretty soon, my daughter-in-law is going to come and take some of them over to enter in the fair."

As I left, I felt deeply blessed by my opportunity to listen to and observe the richness and love between Archie and Lorene.

# Velma

TAMARA HAD GIVEN ME VELMA'S NAME, because Velma had worked with Edna at Macklanburg-Duncan.

A few days after I met with Archie and Lorene, I drove to Velma's spacious home in south Oklahoma City. When the door opened, I gazed upon a lovely, tanned, beautifully coiffed, silver-haired lady, who was dressed smartly in a blue-and-white striped shirt and white slacks.

As we began, Velma told me that after her first divorce, she began working at Macklanburg-Duncan in the early 1970s. Velma also related that after Edna retired, she and Edna had continued a close friendship.

When she worked at Macklanburg-Duncan, Velma said, "I had all kinds of different jobs. We made all kinds of building products, like caulking and screens for windows. Edna and I usually worked in the same department. In the last department that I was in, we made levels. I worked back in the dirty part of it, too. I worked there over 25 years. I should have stayed on and worked a little longer. I get lonesome. I don't see nobody.

All my friends like Edna and Carol that I used to talk to on the phone have died.

"I sure miss Edna. We always talked two or three times a week. Everytime I would see her, she would ask me what was going on at Macklanburg. She didn't want to retire. She was always saying, 'Oh, I wish I was back out there.'

"Macklanburg-Duncan was a good place to work. Everybody joked and had a real good time, and lots of women worked there. Even some of my kids worked there after they graduated from high school. As a company, we always had good times. We had picnics in the summers at the zoo and Christmas parties, and there would be a party every time somebody retired. But, after Mr. and Mrs. Macklanburg died, the business was sold and nothing was the same after that."

Returning to Edna, Velma said, "Edna got along with everybody. We would talk and laugh about OU [Oklahoma University]. She was a big OU fan, and so is my husband, Leo. We'd buy season tickets but, since I've known her, I don't think Edna ever did go to any games, but she had to watch them on television.

"When Edna's eyes got so bad that she couldn't drive, I would take her to her doctor's appointments. I was just shocked when Carol called me and told me that Edna had passed away."

I asked Velma to describe Carol's and Edna's relationship.

"Ever since I've known Edna, she was with Carol. I guess their relationship was real good. They lived together for many years, and they never argued that I know of."

I then asked Velma about herself.

"I was born in 1933 and raised in Arkansas. I was one of 13 children. We lived on a farm that my brother still owns. We had to raise potatoes and corn and, if we didn't raise a good crop, the winter was rough. We had to milk about 50 head of cattle before we went to school in the morning. When we got home, we had to milk the cows again. We sold milk. We also raised chickens and sold eggs. My dad also raised hogs, and every year we would butcher two or three of them and cure them with salt in the smokehouse. We didn't have an icebox and, by the end of winter, the hog was getting a little tainted.

"My mother and dad were from big families, all Baptist. When we were kids, we had to go to church in a wagon. Daddy always made sure we'd go to church. If we had a revival, we all had to go to church every night.

"I was about 13 or 14 when we got our first car. We got an old pick-up. Daddy tried to learn how to drive. Then, he had a real bad wreck, and he wouldn't drive no more. Then, the kids started learning how to drive."

Velma added, "Daddy and his brother-in-law were going to build us a house out of cement block. Neither one of them knew how to build anything. While they were building the house, we

slept in the barn on those old iron beds, sometimes three or four in a bed. We put our stove and table in the smokehouse. Eventually, they got the house built, but we didn't have running water for years. But, we had a good well, and we'd draw the water out of the well with a bucket. We had an outhouse and used Montgomery Ward's or Sears' catalogs to wipe."

Velma inserted, "I played basketball when I was in school. My dad got us all through high school. After that, we were on our own.

"I have three kids, a boy and two girls, five grandkids, and two great-grandkids. After my kids were teenagers, me and my husband got a divorce, and I had to go to work to support us."

I later learned that Velma married her third husband, Leo, in 1983 and, at 78, Leo is still working.

"When I first met Leo, he was a milkman. Then, he started working as a salesman for his nephew that owns a food company. Leo said that I'd have too many honey-dos for him if he retired. He will probably retire in a couple of years, but he'll work as long as he is able. His work is not too hard. He just drives to a lot of stores to get orders.

"Leo was the best marriage I ever had. Leo's a good person. He's got three kids, and it's all one big family when everyone gets together. We had 42 people here last Christmas."

I asked Velma if there was anything in her life that she wished she would have done differently.

"I'd tried to have studied my books more and be more educated. But we just were barely able to get to school. When we got home from school, we would have to work until dark and, in the mornings, we would have to work one or two hours before school. We rode a bus most of the time, but sometimes we had to walk three or four miles to school.

"None of my kids went to college. When they graduated from high school, they got married and started raising families."

During our time together, I could see glimpses of Velma's backyard and a swimming pool that shimmered in the sunshine. I commented on its beauty. As I prepared to leave, Velma asked if I would like to see her backyard. As we stepped onto her patio, I was greeted with a lovely panorama of a pool that was surrounded by shrubs that had been manicured to perfection. Velma proudly proclaimed that she was the gardener, and I was suitably impressed by her artistry.

As I left that day, I was grateful for the window into Velma's life, and a glimpse at Edna and Carol through the eyes of another.

# Jan

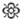

I BEGAN MY ACQUAINTANCE with Carol's long-time friend, Jan, by telephone. I prefer to meet the historians in person, so we can become more comfortable and engaged with one another. I hoped to go to Florida to meet with Jan and another friend of Carol's, Ann. However, Ann would not return to Florida from her Northern summer home until early December. As I talked with Jan, her effervescence grabbed me over the wires, and I couldn't wait until December to plumb her depths.

Jan began, "I am approaching 80. I don't know what 80 feels like, but I don't feel it. My family is of German extraction, and I was born and raised on a farm in Ohio during the Depression. My parents, two brothers, and I got up at 3:00 in the morning to milk 36 cows, and we went to sleep way before the chickens. We also mowed hay and doodled it into rows. Then, I got the job of sitting on the bails and twisting the wire. You used a tractor if you were lucky enough to have one. We had a very old one, and we fixed it a lot with baling wire."

I asked Jan to describe her parents.

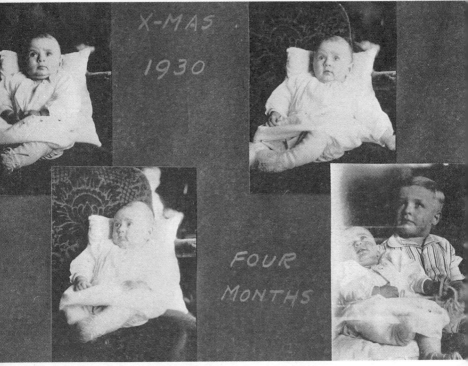

X-MAS
1930

FOUR
MONTHS

**Carol in 1930 at the age of four months. Bottom right, Carol and her brother, Richard.**

"My father was a good father. He WAS a father. My mother had so many stars in her crown that she was top heavy when she got to heaven. My mother didn't know any strangers, and she helped anyone. She was a very kind and generous person."

Jan went on to describe herself by saying, "I'm not always right, but I'm never wrong. One time I thought I was wrong, but I was mistaken." For good measure, Jan added, "I'm pretty easy to get along with, as long as I get my way.

**Carol—Sweet Innocence.**

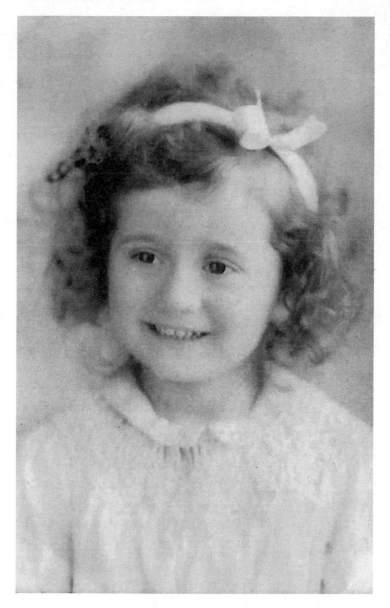

"I was a fancy bartender, a mixologist, at a neighborhood bar and at a downtown cocktail lounge. I preferred the neighborhood bar. I didn't make as much money there, but I knew all the people. The downtown bar was next to a fancy hotel, and the big shots, that you spell with an 'i,' would come over. But, in the neighborhood bar, I'd have 'Lunch Bucket Joe' come in after work for a couple of beers and, on Friday night when he got paid, he'd come in with his wife and kids.

"How I started with Carol was through her mother, Vivian. In 1978, I lived across the street from Vivian. She was a very lovely person, very knowledgeable and considerate. I really liked her. I made her kind of a second mother. Carol's father, John, had passed away a month before I moved there. He was a

(a) Carol, Richard, and their mother, Vivian; (b) Carol; (c) Carol and Richard.

**Richard and Carol and their father, John.**

professor in engineering in Chicago. Vivian said that he was a little controlling, but he was like any other father that had a job that took his mind. Apparently, Vivian and John were well off from John's investments. [Hence the apparent affluent lifestyle as seen in Carol's childhood photographs.]

Carol—A Cutie.

Carol's life of privilege on display.

Carol—Reared to be a Lady.

**Carol—What lies behind that strained smile?**

"From what I can gather, John was a very nice person. He'd have to be to be with Vivian, because she was a living doll. Vivian had taught piano and classical music at the Conservatory in Chicago. Once, when Vivian was having difficulty with a student, she told me that John had offered his solution to her problem by saying, 'If you'd just teach them music and not that long-haired stuff.'

"Vivian wanted to teach me to play the piano, but I wouldn't do it. I told her that my German piano teacher put pennies on my fingers and, if they fell off, she'd crack me. That didn't last long. Vivian told me that she wouldn't crack my fingers, but I still wasn't interested."

I asked Jan if Vivian had told her any stories about Carol's childhood.

"Vivian once told me that when Carol and her brother, Richard, were small, they would run around the dining room table and race little cars. Vivian said that she noticed that they were wearing tracks in the varnish. Rather than interrupt the children's play and so John wouldn't see, she just used a tablecloth. John did not discover the tracks until they moved to Florida in 1962. Then, he revarnished the table.

"Vivian also told me that she came home one day to find that Carol had set the dining room table with china, crystal goblets, and the good silverware. Vivian said that she asked Carol what was going on, and Carol responded, 'Well, I did it. I joined the Marines.' Just a little bit of defiance.

"I took Vivian on errands and to her doctor's appointments. I had a great deal of fun with Vivian. I teased her a lot. Carol was adopted. She couldn't have been born into a nicer family. When I moved, I told Vivian that I would be just a few minutes away and that if she needed anything that I would be there in a flash.

"After I moved, Vivian told me that when my husband, Elmer, and I were away from home that Carol would come over and mess around in our flowerbeds. After we moved, Vivian said that when the new people moved in, Carol went over and said to them, 'She took good care of this garden, and you are supposed to do the same thing.'

"Carol came to visit every year for one to two weeks before Thanksgiving. Since Carol didn't drive, we coupled up to take

Vivian to her appointments. That is how our relationship started."

Describing Carol, Jan stated, "Carol could be very direct and opinionated, but she was a very nice person, and I dearly loved her. She once said to me, 'You are full of piss and vinegar, and you have a motor mouth.' She was right. If it crossed my mind, it came out of my mouth. People always knew where they stood with me. As I got older, I began to briefly pause and think about what I said. When Carol came to visit her mother each year, she did her Christmas shopping. Even after her mother died, Carol would come the same time of year to visit me and do her shopping. One time I saw her packing her suitcase with white radishes and green corn. Carol turned to me and said, 'You can think it, but dern you, don't you say it.'"

I asked if Edna ever came on these annual visits.

"No. I knew Edna only by telephone. If she answered the phone, she would chit-chat with me for a few minutes, then tell Carol, 'Jan's on the phone.' When Carol came to Florida, Edna and her sister would go to the lake and fish.

"I guess Edna spent a lot of time reading. She read a little bit of everything. When she finished reading a book, she would put a little 'x' inside the cover. Then, Carol would box them up and send them to me."

Returning to Carol, Jan said, "Carol was very thoughtful and generous. To keep her hand in music, Vivian had been

teaching a little girl down the street from her to play the piano. When Vivian died in 1982, Carol gave the little girl her mother's metronome and music books. Carol was always giving gifts and, when she bought a gift, she gave everything that went with it. Like, one year she bought cinnamon brooms. They each came with a bottle of cinnamon oil, but Carol bought extra bottles of oil. When I asked her why, Carol said, 'Oh, they will never be able to find this back in Oklahoma.' Another time, when we were having root beer, I mentioned to Carol that we could not get good root beer here. She wondered what was the best? I told her, in Ohio, I always bought Barrel Head and thought it was the best. Well, when she got off the plane on her next trip to Florida, she was carrying a box tied with a rope. She handed it to me and said, 'Here, this is yours.' It contained 12 bottles of, you guessed it, Barrel Head Root Beer. However, the most important gift that Carol gave me was friendship.

"When Carol inherited her mother's silver, which was appraised at $53,000, she divided it equally between her brother Richard's two children and sent it to them. It hurt Carol very much that she never received a thank-you card or even acknowledgement that the silver had been received."

Jan added, "Carol would never permit me to buy or send her anything, but she was always giving me things. No matter what she said, I made her a bunch of cobblers aprons, and she wore

them when she was still working. I also crocheted afghans and doilies for her.

"Carol was the kind of person who talked when she wanted to talk, and she only told you what she wanted you to know. I kind of got it in my head from Carol's innuendo that she had been raped. She wasn't exactly a man-hater, but she didn't exactly care for them. She liked my husband and the men she worked with, and she sent Elmer many gifts.

"Over the years, Carol sent Elmer all sorts of tools and garage gadgets. She also sent him things from the Franklin Mint. One of her most unusual gifts was an iron dinner bell in which the base was in the shape of a steer's head and the horns held the bell."

I next asked Jan about Carol's work life.

"Carol didn't like to talk about herself, but I learned about her from little bits and pieces of conversation. When she was in the Marines, she was stationed in Washington, D.C., at the Pentagon. She had an accident there and injured her hand. Also, when she worked at L.S. Bearing, she injured her eye. Carol eventually had three or four transplants to her eye, but they were all unsuccessful. It seems that, in the end, the doctors learned that her body was rejecting the transplants because of the suture they used. Carol finally said, 'That's enough. There's lots of others that could benefit from the next one [cornea] that comes up.'

"Carol didn't like the Marines very much. After she left the Marines, she decided that she needed to be on her own, so she moved to California for awhile. While there, she went to cosmetology school. Cosmetology was just a side thing for Carol. Nothing serious. When she came to visit, she always cut my hair. She did a good job."

Jan didn't know how Carol met Edna or why she moved to Oklahoma.

I then asked about Carol's work at L.S. Bearing.

"For Carol, her work at L.S. Bearing was just a job. She talked about how dirty it was, like any factory job. It was a means to an end. She had to have worked there 25 or 30 years. She retired at 65 and died at 75."

When I asked Jan about Carol's brother, Richard, Jan replied, "Carol told me that Richard committed suicide when he was a young man. Vivian was kind of in denial. Apparently, Richard's wife was a spend-thrift, and he got overwhelmed by being so deeply in debt."

I then asked about Vivian and John's relationship with Richard's two children, Richard and Susan.

"They were truly grandparents, but I don't believe Vivian saw her grandchildren very often. I only know that when young Richard got married, he and his bride came to see Vivian."

Making a sharp turn, Jan said, "I believe in karma. Whatever you give out, you get back. There are forty Lutheran ministers

**Richard's wife, Richard, Carol, Vivian, John, and Richard's children, Richard and Susan.**

in my family, starting with my great-grandfather.  Once I said to my grandmother, 'I believe heaven and hell is right here on Earth.' It upset her, so I patronized her a little.  She was nearly 90 years old.  I believe if you do good, you get good back and, if you do bad, you get bad back, but we all can change our ways. We can choose to do good."

Without missing a beat, Jan continued, "Elmer is my second husband. We were married in 1965. I had a rotten first marriage, and his wasn't too great either. When we married, he had four children, two girls and two boys, and I had two children, a girl and a boy. Now, between the two of us, we have six children, but they are all mine. We have 20 grandchildren and 29 great-grandchildren. Our kids are prolific.

"Elmer is 81. He was born in 1925. He was a toolmaker for General Motors. He retired in 1975, and I retired about the same time. Then, we bought a motor home and traveled all over the United States. When it was smaller, we used to like to go to Laughlin, Nevada, for the gambling, but we haven't been there since 1991. The last time we were in Las Vegas was in 1966. I didn't like it. It got too glitzy."

On my inquiring about her husband, Jan said, "Carol described Elmer as a 'prince of a man.' When Carol's mother died, Carol inherited everything, since she was the only remaining child. One evening Elmer said to me, 'What is Carol going to do with everything?' Then he said, 'Why don't you drive her back to Oklahoma.' After he thought about it for awhile, Elmer said, 'It is about time for us to go to Ohio and see the kids. Why don't we load up the station wagon with Carol's things, and we will take her to Oklahoma and then drive on to Ohio.' That is why Carol called Elmer a 'prince.'"

I interjected, "You are a treasure."

Jan retorted, "I am kind of tarnished. I can't get out in the rain, or I might rust."

As we concluded, Jan said, "We are approaching the anniversary of Carol's death. I had just mailed her birthday card when Tamara called to tell me that she had died. Carol had not told me that Edna had died or the severity of her own illness. I was shocked. I had just had an artery bypass in July and, in not telling me, Carol was being nice to me because of my health problems. I miss her terribly. Carol and I had our differences over little stuff, like vegetables in luggage but, in 27 years, we never had a big disagreement."

As we concluded, Jan said, "Carol will always be remembered as a dear friend. Even if she always said, 'I know that I'm a pain in the ass.' She is sorely missed."

# Ann

By November, my schedule had changed, and I was unable to go to Florida that December. So, I interviewed Carol's parents' long-time neighbor, Ann, by telephone. Ann first told me that at 66, she is a grandmother and recently became a great-grandmother. Ann related that in 1962, she, her husband, and their two small children moved next door to Vivian and John. Currently, during the winters, Ann and her husband continue to reside in the same residence, but now they have taken on Vivian and John's roles as active participants in the lives of their new neighbors and their young children.

Ann began, "I loved Vivian and John so much. Carol, I did not know as well. She was very quiet, but Vivian and John became like our family."

I asked if Edna came with Carol on her yearly visits.

"On occasion, Edna would come to Florida with Carol, but Vivian would say, 'I just wish she wouldn't bring Edna.' Because Vivian wanted Carol all to herself, and the other thing. [Referring to the nature of Carol and Edna's relationship.]

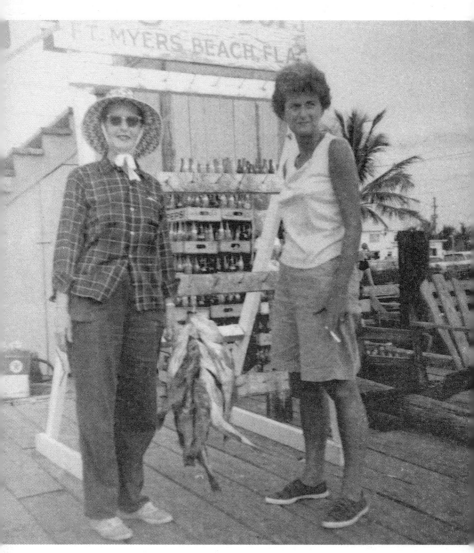

**Edna and Carol—Gone Fishing.**

"When Carol would come, Vivian sewed her tops. Vivian liked to sew for people.

"Once, I went to the airport to pick up Carol and Edna. They were very masculine in dress, and it was very shocking to me. On another trip, when Carol came alone, I invited Vivian, John, and Carol to dinner. For dinner, Vivian asked Carol to wear a dress, and Carol was very irked."

Returning to Vivian, Ann said, "She was full of life, and I had the greatest respect for her. She was beyond compare. I had never before met anyone like her. Vivian was my friend and mentor. She taught me and my daughter to play the piano. Carol once said to me, 'You couldn't have had a better piano teacher.' On Vivian's death, Carol gave me Vivian's piano.

"Like Vivian, Carol also taught piano at the Conservatory but, when she was in the Marines, Carol hurt her hand in a file cabinet, which impaired her playing. At least, she would say to her mother that she could no longer play. Also, where she worked in Oklahoma, Carol hurt her eye."

Ann felt that she would be betraying Vivian if she were to share more about their intimate conversations but, as we concluded and with tears in her voice, Ann said, "Vivian was a wonderful woman. I loved her so much. I still miss her."

# ~ SEVEN ~

# Judy and Her Neighbors

I KNEW FROM TAMARA that Judy had lived most of her life across the street from the house in which Carol and Edna resided for 45 years. However, for health reasons, Judy had sold her home and moved into an assisted-living facility.

I first met Judy by telephone. After I introduced myself, I told her about the book that I was writing and that Tamara had told me that she would be a rich source of information.

Judy retorted, "Well, I don't know about that, but what I don't know, I'll lie about or make up."

I immediately knew I had a corker on my hands and I was in for a fun ride.

For my first meeting with Judy, I drove to another "senior community," using Judy's words, located near the one in which Dot resided. As I approached the front porch, I spied a sign reading, "Grandma's Rules: Buy them presents, feed them sweets, send them home." When the front door opened, I was face-to-face with a woman walking unsteadily with a walker, who was obviously in very poor health. I thanked her for allowing me to visit her, and I hoped that I wasn't intruding.

Judy promptly quipped, "No, I was doing what I am always doing—nothing."

Judy was wearing a bright, yellow T-shirt and an equally bright, blue pair of pants. Her chest bore the T-shirt's picture of two teddy bears munching on cookies, with the inscription, "In the cookies of life, grandmas are the chocolate chips." Judy has five grandchildren.

I was later to learn that Judy had chronic obstructive pulmonary disease, congestive heart failure, kidney failure, and had been a brittle, insulin-dependent diabetic for 34 years. She then added, for good measure, "And my left little toe hurts."

Judy was obviously one that did not complain about her health. She later requested to see Carol and Edna's yard after I had completed its restoration and added, "If I live that long."

She told me that she moved from her neighborhood home and into her two-bedroom apartment in June 2005. She commented that it had been difficult for her to move from a spacious eight-room home into such a small living space and that she had to part with many of her precious antiques and rocks. It appears that Judy is also an avid rock collector.

Judy then asked me if I wanted to see her favorite rock.

"Of course, I want to. I love rocks," I said.

With her halting gait, Judy retrieved an exquisite piece of amethyst, measuring about five inches by ten inches, and placed

it on the table between us, where it stayed for the remainder of our conversation. I was delighted by its presence.

During our conversation, Judy asked me if I wanted to see her "pride and joy." I responded in the affirmative. Judy promptly led me into her bedroom where I saw a beautiful, hand-crafted, oak bedstead that was made by her maternal great-grandfather for the occasion of her grandparents' wedding, which was held in 1862.

"My great-grandfather worked for a furniture manufacturing company, and he stayed after hours to make this bedstead," Judy said. "Originally, the bed had rope slates, straw ticking, and a feather mattress. I told my daughter, Lisa, that I wanted to be cremated, and the bed goes with me. Lisa said, 'Mom, we will cremate you, but the bed goes with me.'"

A few minutes later, Judy took me into her second bedroom and showed me a photograph of her grandparents, in which their features were so pristine that they looked as though they could speak. On the wall beneath the photograph was a colorful painting of a clown, bedecked in red, that Judy had painted in the ninth grade. As we turned to go into the living room, I spied Judy's computer sitting on the pull-out flour board of a remarkably well-restored, antique Hoosier. As we took our seats, Judy motioned to a lovely oak dining table and commented that it was her maternal great-grandmother's.

Judy began her story by telling me that she is 64 and was first married at 19. The couple divorced after four years of

marriage. As to the reason, Judy remarked, "Because I can't handle infidelity." After the divorce, Judy moved back home and lived with her parents. By her first marriage, Judy has two children: Cheryl Ann, age 47, who lives two miles from her, and David Scott, age 42, who lives in Oklahoma City.

After divorcing, Judy and her children lived two years with Judy's parents. During this time, Judy attended Oklahoma City University. She said, "I was stupid, dumb, and foolish, when I dropped out of school and married my second husband." The newly married couple moved to Illinois.

I asked Judy why they moved.

"Because he said to me, 'I'm moving back to Illinois, and you're coming with me.'" After eight years, Judy again divorced because of her husband's infidelity. After her second divorce, Judy returned to Oklahoma City and bought the house two doors down from her parents and across the street from Carol and Edna.

By her second husband, Judy had Lisa Marie, age 39, who lives one-quarter of a mile from her, "as the crow flies."

## JUDY'S WORK LIFE

On being asked about her work, Judy responded, "I worked almost all of my life in drafting, and I fought male chauvinistic tendencies the entire time. I took drafting in high school. I was very good. I was the only girl my drafting teacher ever taught. After I took the course for about a month and a half,

the teacher would come in and give me the course schedule for the day. Then, he would leave, and I would teach the class. The boys didn't like it very much."

When Judy returned to Oklahoma City after her second divorce, she worked for C.M.I., Construction Machinery Incorporated, until 1979.

I asked her about women in her male-dominated profession.

"Only toward the end of that time were women in my profession. The men picked on me. Once, there was a big, black snake that had gotten fried in some machinery, and the guys wrapped that snake around my drafting table leg. When I saw it, I said, 'What the hell is this doing in here?' and I picked up that dried-up strip of snake, threw it over my shoulder, and walked outside. [Judy rolled her eyes, mimicking the men's response to her bravado.]

"On my 40th birthday, the guys threw a birthday party for me, and my future husband, Joe, gave me a bottle of red hair dye. Nobody thought I'd use it, but I did." On being asked how the color looked on her, Judy responded, "Horrible."

I laughed and said, "You're delightful."

Judy immediately retorted, "Of course I am and, if you don't believe it, I'll beat the hell out of you and keep telling you I am."

I requested another work story.

"We had two female secretaries. One day, we went into the bathroom. The guys had reversed the bathroom lock [Judy

mimicked the use of a screwdriver] so that it locked from the outside, and they locked us in the bathroom. We stayed in there until the head engineer came by and heard us pounding on the door. Those guys got their little cans in trouble."

Judy smiled and said, "I knew that the men wouldn't do those pranks if they didn't like me, but you have to work at being liked, especially if you go into a strange environment."

## JUDY'S THIRD HUSBAND—JOE

When Judy first mentioned Joe, I sensed that he had been the love of her life and, as she talked of him, my suspicion was confirmed. As she spoke of her third husband, sadness and longing washed over Judy's face and tears glistened in her eyes.

"Joe and I were married on March 4, 1978. He was born in 1925 and was 17 years older. He was very quiet, very, very intelligent, and talented at almost anything he did, including electronics, plumbing, and carpentry. He replumbed my house. He could do anything I asked him to do. Joe was Italian. His parents immigrated to America."

I asked Judy why she quit work in 1979.

"Because Joe wanted me to. I didn't really care. We had all three of my children still at home, and Joe was so very good to my kids, and that made him even more special to me. After I had been home for awhile, I got very bored, so I started working for a little maternity shop. After a year, the lady that owned it died. Joe and I talked about it, and we bought the store. I

worked there for three years, until Joe got sick. Then I closed the doors and stayed home with him.

"Life with Joe was too short. We were happy. We were content with each other. Shortly after we were married, we had an argument. Joe took his car keys and went for a ride. When he walked in the door, we both said, 'I'm so sorry.' We were each adjusting to the other.

"After we were married for eight years, Joe came down with colon cancer and had to have that removed. When they were in there to remove part of his colon, they found that he had an aneurysm, but they didn't remove it because of the risk of infection. He did not need chemotherapy, and, three months later, they went back in and repaired the aneurysm. Joe was just fine for about two years. Then, we found out that he had tumors in his liver and lungs. He began chemotherapy at that time, and he never got sick. He was taking his treatments at Baptist Hospital and, afterwards, we would eat at a barbecue place across the street. He never lost his hair, and the cancers began to shrink. He took all the chemo that he could have, then the cancers started growing again. It was just a matter of time before he left. Joe died on August 30, 1990, one week after my birthday. I think he hung on, because he didn't want to die on my birthday.

"I truly miss him still to this day. I get mad when something breaks and say, 'Oh, Joe, why aren't you here to fix this?' The poor man had to die to get away from me."

## JUDY'S PARENTS

I asked about Judy's parents.

"I loved my mother. I loved her dearly, but I didn't like her. She was a very possessive person. She never gave anything to anyone. There were always strings attached. My brother, David, is three years older, and she pitted David and I against each other. She would tell David, 'Why can't you be like Judy, she is so nice?' Then she would tell me, 'Why can't you be like David, he is so smart and makes good grades?' She made us both feel dumb and unloved.

"David was the intelligent one, and I was the talented one. David was smart enough to live in their world and do what they said. I lived in their world and did what I wanted. It made for a hard life.

"Mother was born in 1903 and died in 2000. She was always the monarch of the family. She ruled the roost. When David and I were in our early teens, she went through menopause for about eleven years, really, really bad. It was hard for us. Mother and I could never get along very well. Probably, because I was so much like her. I try not to be like her, but it comes shining through once in awhile.

"My father put Mother on a pedestal, and we could never reach her. She was too high."

I asked why her mother was placed on a pedestal.

"Because he loved her, pure and simple. I put Father and Mother on a pedestal. Daddy kept coming down and

working hard. Mother stayed up there. She knew that she was better.

"My father was born in 1896. He was a soft-spoken man. He didn't get a chance to talk much. He was in the background. He was Irish and Scottish and had an eighth-grade education, but he was a very, very intelligent man. He had a lot of common sense. He adored, even idolized, his family. For forty years, he worked for Tinker aircraft as a welder and maintenance man. He understood the airplanes so much that the engineers and the high muckity-mucks would come and lay out the blueprints in front of him and ask, 'Do you think this will work?' If he said no, they would go off and study it and often come back to him later and say, 'You were right.' My father died in 1977, on Flag Day.

"I didn't know my father's parents. His mother passed away when he was quite young, and his father died three years before I was born. Mother's family was English and Welsh. She had seven brothers and seven sisters, and she was the middle child. When she was 93, she was in the hospital, and her younger sister told me some horrific things that happened to Mother as a child. At that moment, she came off her pedestal. She became a human being, and I could forgive her.

"I have always been interested in my brother David. He is so smart. He graduated from the University of Oklahoma and worked in the upper echelon of the Post Office. He traveled all over the world to hold conferences. He is now retired and

lives in the South. He had one son, Michael David, who now has five children. Michael David and his wife are as sweet as they can be."

Judy was born on August 23, 1942. "Mother and Father moved into the neighborhood before I was 10 years old. I am not a shy person, and I went around and talked to all the neighbors. They all took me under their motherly and grandmotherly wings. Often, the neighbors lived there many, many years. They moved there when they were young, and they died there." Judy then proceeded to give a detailed account of her impressions over the years of her various neighbors, which included Carol and Edna.

## MRS. SUMARA

Judy talked first of her next-door neighbor, Mrs. Sumara. "She and her husband came from Hungary and had one child, Johnny, who was born in 1935. Mrs. Sumara was a short lady and, in the last 40 years of her life, she was stout. She had a determined walk, not a glide. If you got past Mrs. Sumara's gruff, you could like her. Mrs. Sumara was loving to those in the family, but she was very cold and distant to anyone that was not family. She never talked to the neighbors, but Mother and I were so much alike, we forced ourselves on her." Judy had told me in advance that she liked to talk.

"Mr. Sumara passed away about four years after we moved into Mom and Dad's house. He was a very quiet man, very

reserved. He hardly spoke with anybody outside of his family. The Sumaras had owned a grocery store, a little neighborhood market, but it closed many years before we moved to the street.

"The Sumaras' son, Johnny, had intelligence coming out the ears, but his common sense was nil. Johnny thought he was the rogue of the neighborhood, but he was a good kid. He moved away a few years after we moved next door. What I know about him is from his mama's talking about her baby boy, Johnny. He hated to be called Johnny. He said that his name was John. Johnny married a lady, and they never had a child. Mrs. Sumara wanted a grandchild so bad that when I had my first child, she came over and offered Mother $10,000 to be the child's grandmother.

"After Mr. Sumara died, Mother talked to Mrs. Sumara every day. Mrs. Sumara didn't want to ask for help. She would rather go without than ask, but Mother would call Mrs. Sumara before she went to the store and ask her if she needed anything. One day, in 1975, she did not answer her phone. Mother had a key to Mrs. Sumara's back door, and we found her dead. She was sitting on her old divan, hard as a rock, still with a drink of pop in her hand."

At this point, Judy said, "I am saying some bad things about these neighbors. They had a thick crust, but if you got underneath their crust, they had big hearts."

## ERMA

Judy next turned to her neighbor, Erma, who lived two doors west of Carol and Edna. "I love Erma with tears in my eyes, but she is a very strong-willed, opinionated, poor, rich lady. Erma is loud, boisterous, and very frugal, very frugal, but she is a sweetheart." Judy related that Erma grew up in the home that she later occupied for many years with her sister, Dorothy. Neither sister married. Both sisters worked, until 1968, as beauticians in their shop in a strip mall that their father owned that was located three blocks from their home. At 92, Dorothy has dementia and lives in a nursing home, and Erma continues to occupy the family home alone. Judy added with her usual flare, "Until two years before Dorothy went into the nursing home, the sisters were still dyeing each other's eyebrows coal black."

Judy humorously related what Mrs. Sumara said about Erma's father, Mr. Polkey, "Him's got him's first nickel him's ever made." Judy took it from there. "Mr. Polkey was German and a strict disciplinarian, but he had a big heart. The Polkeys had three children, Fred, Dorothy, and Erma. His family was all to Mr. Polkey. If someone in his family needed something, he was there. For instance, a female relative in Germany had a child, Gisela, and she couldn't take care of her. In 1952, when I was 11, Mr. Polkey went over to Germany, brought Gisela back, and raised her as his own. But he wouldn't adopt her, because she wasn't 'his blood.'

"When we moved into the neighborhood, I was the only child, but, when Gisela came, she was just a year older than me, and we played together all the time. Often, Mr. Polkey would come out front and bellow like a bull moose at us kids. I was always scared of him, until one day, as he turned to walk away, I saw a gleam in his eye. I realized, 'He's full of bullshit.' From then on, every time I saw him, I'd go up and give him a hug. He would sort of resist, but, if I didn't come and give him a hug, he would have a hurt look in his eyes and, when I passed by, he would slightly hold out his arms. He was just an old, softy gruff. I was the only one of Gisela's friends that snookered him.

"Mrs. Polkey was very quiet, and what Mr. Polkey said was law. The Polkeys loved each other, but they communicated by yelling. Mr. Polkey did not say, 'Please, go take the trash out.' It was a bellow, and the kids didn't say, 'I'll do it later.' Oh, no, no, no.

"Fred was far above his sisters. In the German families, women were not the equal of the male heirs. In most of society in today's world, it is the same thing. Erma and Dorothy had to claw their way up in their father's life. They worked hard to have their own identity. I don't know if they ever made it.

"Fred was five years older than Dorothy, and Erma was the youngest. After he married, Fred and his wife lived about a mile from his parents' home. They had two children, a girl and a boy. Fred has been gone for 20- to 30 years."

Never missing a beat, Judy continued, "Erma is very loud, very opinionated, very outgoing, and very down to Earth. She had a lot of true friends. All you would have to do was to ask her to do something, and she would do it if she possibly could. Erma was also very noisy. She knew everything that was going on in the neighborhood. Erma didn't like anyone encroaching on her property. She did all of the outside work and was a fanatic about keeping her yard mowed, trimmed, and picked up.

"Erma and Dorothy were like day and night. Dorothy took care of the house. To be honest, Dorothy didn't have much of a personality, but I loved her to death because she was such a sweet lady. She was a big woman, about 5'9, and she always felt like she was really, really fat, but she might have weighed 180 pounds. Erma was about 5'7, and both sisters were stocky when they were younger. A lot of people asked me if they were butches. Erma acted like it, the way she walked and stood, but how does a lesbian walk and stand? Erma walked around like she was rough and tough, like she had a corn cob up her ass. Ten years ago, I would never have back-talked Erma, because she could have slapped me down the neighborhood."

I asked Judy about her friend, Gisela.

"Erma and Dorothy treated Gisela like she was a little kid sister. When I was there, Gisela never hung around Erma and Dorothy, and she didn't look anything like them.

"Gisela had two different personalities. At home, she was quiet and reserved. Away from home, she acted like, 'I'm better

than you. I'm prettier than you. I've got nicer clothes than you have.' Once in high school, we met each other walking down the hall, and Gisela didn't speak and looked right through me. Later, she married the school's basketball star, and they lived in Texas. Over the years, the only time we ever talked was when we tried to get the class reunions organized. Gisela passed away four years ago."

To complete her story, Judy added, "When the Polkeys came from Germany, they were very poor and very frugal. When Mr. Polkey died, he had 37 business properties and 64 residential properties. His will said that his three children could equally divide the residential properties, but the business properties had to stay in a trust for his two grandchildren. However, what was earned, after expenses, from the business properties, the children could divide."

## CAROL AND EDNA

Edna bought her house shortly after Judy and her family moved to the neighborhood, and Carol moved in a year or two later.

"I was still a kid when they moved in. My first impression of Edna was that she was very stand-offish. She did not talk a lot to the neighbors, but I picked on her. I'd wave at her or say 'Hi' or, if she was getting out of her car and had groceries, I'd go help her carry them in.

"At first, Carol was very reclusive and very cautious about talking to anyone, but she loved to talk about her garden and

yard. I'd go over and sit down on the ground with her, and she'd be pulling weeds, and I'd start pulling weeds.

"Very slowly, Carol and Edna opened up to me. They were very sweet people. If you asked, they would do anything they could for you. They were very generous people, but, until they knew you well, they were very cautious about what they would tell you."

During our discussion, Judy asked me, "Why are you doing this?"

I proceeded to tell her the story of how I found the house. (For details, see the Preface.) I got to the part of the story when Carol's disapproving spirit was riding me and calling me "girlie girl," while I was hot, dirty, and on all fours, pulling Bermuda roots out of the flowerbeds. I related to Judy that I had told Carol to back off and that if she hadn't smoked so many cigarettes all those years that she would be tending these beds.

Judy was obviously dismayed by my retort and said, "You shouldn't have said that. It is her yard."

I felt appropriately chastised and promised that I would apologize to Carol the next time she came to visit me in the garden.

Judy picked it up from there. "When Carol was able, she was immaculate about that yard. She worked her fanny off. In that yard, Carol's motto was, 'If you don't do it right, you do it again.' I used to love to work in my garden and yard and,

occasionally, I'd ask Carol about this or that, even though I knew the answer. It made her feel good.

"Carol loved rocks. Carol and Edna traveled all over the United States and brought back rocks. Every time we took a trip, we would bring her back a big rock.

"Edna was an indoor person. She would come out and sit on the porch in the cool of the early morning or in the evening. She would ask you all kinds of questions, noisy questions but, when you turned the tables on her, she would skirt around it. Edna was very good at not saying much, but she was always so friendly and so welcoming. However, Edna was very cautious with men. I don't think she particularly liked them. She had lived her long life without one, and she didn't need one.

"Carol and Edna related to each other very well, but they were a reserved couple. They did not go out of their way to get to know people. I was always having impromptu parties and inviting the neighbors to bring their chairs and drinks to my front yard, and we would talk and talk. When Carol and Edna came over, they would always sit next to each other. They never mingled.

"However, Carol, Edna, and I would take walks, but Edna had really bad rheumatoid arthritis and her hands were crippled. At the last, she had to walk with a walker, because her arthritis was getting so bad."

## THE WILLIAMSES

After Judy's family had been on the block for awhile, the Williamses moved in across the street and two doors east of Carol and Edna. The Williamses had two children, and their son, Bill, was Judy's age.

"Bill was a show-off, very intelligent, and had potential. When he turned 16, his mom and dad bought him a brand-new car. He was showing off to his friends, ran up an incline, and rolled his car. He was killed instantly.

"His death scared the hell out of me. We both had started driving at the same time. I was a good driver. I drove fast, but I wasn't reckless. However, there wasn't one person that would drag with me, because I always won. They wouldn't play chicken with me, either, because I wouldn't quit.

"I didn't have a car, but I drove my parents' 1955 Plymouth, and I never put a scratch on it. Mom and Dad would check the gas gauge to see how far I had driven, but I would go pick up all my girlfriends, and we would count all of our combined change to put gas in the car. Mom and Dad figured that out. Then, they started checking the odometer. Then, I found out how to disconnect the odometer. That worked just fine, until one day I forgot to reconnect it, and my brother and parents couldn't figure out why the odometer didn't work. They took it into the shop and had it repaired." Apparently, that ended Judy's odometer career.

The Williamses moved shortly after Bill's death.

## LARRY AND YOLANDA

In the early 1970s, Larry and Yolanda moved in next door, on the east, to Carol and Edna.

"When they first moved in, they were very stand-offish and did not communicate with anyone. When their son, Kevin, was born, he was like every other child—mischievous. The older neighbors were always calling Yolanda and Larry and complaining about Kevin, but he was just being a kid, and he is now a fine, young man.

"As the years rolled on, Larry and Yolanda started to get to know everyone, and they are the nicest neighbors that you could ever want to have. If you had trouble, Larry was right there, and Yolanda would help if she could. Once there was a cat underneath the hood of Yolanda's car, and she turned on the ignition. She came over and asked me to help. There was blood and guts all over the place, and I cleaned them out. Toward the end of Carol and Edna's lives, I would take Carol to the grocery store, and we'd come back with 15 sacks. Larry would see us, come out, and carry in the groceries. I got where I would pull up and toot the horn, and Larry would be right there to help.

"I don't believe you could ever have nicer neighbors than Larry and Yolanda."

## RALPH AND CINDY

After Eva died, Ralph bought Eva's house, which is located between Erma's and Carol and Edna's.

"I didn't really know Eva very well. She was a school teacher and a very, very private person. Carol and Edna liked Eva, and Carol mowed Eva's yard.

"When Ralph first moved in, he was macho, extremely macho. Ralph told me what needed to be done and how to do it. You don't tell me what to do or how to do it. Ralph didn't get along with anybody for a long while.

"Then, he met Cindy, and they got married. When he and Cindy got home from their honeymoon, I made them a 'Welcome Home' hanging. They softened up after that, and Ralph turned out to be a pretty nice guy. Cindy was not used to living in a lower middle-class neighborhood, but she finally got used to it. Cindy is a very nice lady."

At one of our meetings, Judy had just returned from a doctor's appointment. Trying to be cheerful, I said, "I hope you are as fit as a fiddle?"

She responded, "I'm more like a broken violin. My strings have popped."

In one of our phone conversations, I asked Judy how she was feeling. She retorted, "For someone who is supposed to be dying, I feel great."

Judy had three or four doctors tell her that she was dying. I later asked how she was navigating this transition.

"At first, I cried a lot. I acted real sad and gloomy. Finally, Lisa said, 'Mom, nobody wants to be around you because you

are down all the time.' I don't want to leave this Earth alone. I have always been a very outgoing person. I like to talk to people. I sat down and had a good talk with myself and asked, 'Why stop and be miserable? No one wants to hear you feeling sorry for yourself. Nobody will come back to talk to you.' So, I laugh, but sometimes I am sad, and I am really, really scared to have dialysis. It will cost a thousand dollars a month. I go back next month to see the urologist."

I commented to Judy that in the dying process, people often find solace in spiritual beliefs, and I asked if that was part of her life.

"I have always been spiritual. I was raised in a devout Methodist family. My father was a deacon in the church, and I went to summer Bible school, but I didn't like it because they always made us drink buttermilk and eat unleavened bread."

I laughed and said, "My favorite part of Bible school was the cookies and Kool-Aid, and I doubt if they would have had many takers if they had served buttermilk and unleavened bread."

Judy continued, "I truly believe in God and in Jesus Christ. I pray to my Savior every day, and I believe in His powers. He is the only one that has been able to let me survive this long."

Prior to this topic, Judy and I had been discussing her third husband, Joe. Wanting to bring her comfort, I said, "When you pass, I know Joe will be waiting for you on the other side."

Judy smiled and looked wistfully peaceful.

# Larry and Yolanda

YOLANDA AND LARRY WERE MARRIED in 1971 and moved next door to Carol and Edna in 1972. The couple related their story to me as we sat beneath their patio awning on a hot July morning.

Yolanda began, "Carol and Edna didn't like us at first. We were young, with lots of friends, traffic, and parties."

"Yeah, I didn't do anything to my house at first," Larry said. "I was busy partying and going to the lake. So, I suppose not to look at it, they put up a stockade fence as far to the front curb as the city would allow. The fence made our driveway so narrow that I couldn't drive down it. I got the hint.

"After about three years, I started cleaning up my house. I guess they finally decided, 'He's not moving.'"

Yolanda interjected, "They had a thing against men."

Larry added, "I felt real uncomfortable around them for a long time, until I started doing little things for them and bought part of their stockade fence."

Apparently, Larry's acts of kindness softened the hearts of his neighbors to the west.

Yolanda picked up the story, "Larry is always helping people if something breaks, their car or lawn mower doesn't start, or the fence needs fixing."

"Yeah," Larry said, "I offered to mow their yard for them for years, but Carol was very particular about her yard, and nobody but her could do it to her satisfaction. Carol was so particular about her grass that no one but the postman was allowed to walk on it. About two years before she died, Carol was very upset when she couldn't mow her yard anymore, but she still wouldn't let me do it. She hired someone.

"If I had to get a ball out of their backyard, I asked. Anything I did in their yard, I asked permission to do."

I asked if Edna helped Carol with the yard.

Larry adamantly declared, "Never. It wasn't in her job description. Carol did the yard. Edna took care of the house.

"Carol and Edna were the eyes of the neighborhood. They saw everything. With their front door open, Edna used to sit just inside, and you couldn't see her."

Yolanda added, "Carol was constantly outside on the porch. Every time I came out, she was there. I wondered if I would ever enjoy my front porch without that woman there."

Larry picked up the ball, "After we had been here about three years, we were at the lake and a strange car pulled into our driveway. As soon as they pulled in, Carol and Edna called the cops. Two men got out of the car and opened a window and took pillowcases in. A fireman that lived across

the street saw the whole thing and came over with his thirty-eight. As one of the men backed out of the window, our neighbor put his gun in the man's back and asked what he was doing. He said that the man that lived there asked them to do it. The fireman asked the men what my name was. The name they gave wasn't mine. The fireman tried to hold the two men until the police arrived, but they got away. As one exited into the backyard, the fireman shot into the ground to get him to stop."

Larry chuckled, "When the police officer asked the fireman what kind of shoes the man was wearing, he said that they must have been P.F. Flyers the way that man cleared that fence."

With chagrin, Larry went on to say that the only thing the men got away with was his television remote control, which must have been in his pocket. (And we all know that a man's remote control is about as dear to him as his wife.)

Yolanda continued, "I remember that Edna was always calling and saying, 'I don't want to be a nosy neighbor, but what is going on over there?' We didn't like it at first, but after the theft, we both changed our attitudes."

Larry and Yolanda's only child, Kevin, was born in 1983, and Kevin was a source of consternation and vexation for Carol and Edna.

"They had never had children, and they did not know how to handle Kevin. Every so often they would come out and yell at him," Yolanda said.

Larry added, "Edna was always telling me something that Kevin did. Then, I would ask her when he did it. Come to find out, he would have done it months earlier. I kept asking Edna to tell me when it happened, so I could discipline him."

"Kevin hated it," Yolanda said. "I taught at his school, and his teachers would tell me everything he did. Then he had Carol and Edna at home. He couldn't get by with anything."

Larry related, "One night, when Kevin was 12 or 13, he and a friend were messing around and went over and rang Carol and Edna's doorbell, then ran away. Carol and Edna called the police, and the cops came with lights flashing and whirling. I went to look for Kevin at his friend's house and told him that the police wanted to talk to him."

Yolanda interjected, "Larry, you didn't."

Larry smiled and said, "Yes I did. I just wanted to teach him a lesson.

"That was the last confrontation that Kevin had with them until he was 16 or 17 and backed his truck over their yard, and Carol came out and yelled, 'Don't you drive over my grass.'"

Larry shifted gears. "Carol and Edna were very private. For years and years, I did not go inside their house. I was only allowed inside it in the later years, to carry in groceries for them or to help if one of them fell."

I asked about Carol and Edna's transportation.

Larry responded, "Carol would ride her bicycle to work every day. She was never behind the wheel of a car. If Edna

was not there to drive her, Carol took a taxi. The women only had two cars the whole time we've lived here. The last one was a four-door, maroon Oldsmobile, and it was never out of the garage unless they were going somewhere. [Larry confirmed my suspicion that Carol and Edna were as meticulous about their car and household machines as Carol was about her yard.] Edna stopped driving when she was in her eighties. Then, their main source of transportation was a friend or a taxi."

Picking up a new thread, Yolanda said, "It was the strangest thing. If we bought something, we would show them. Then, they would buy one just like it. [Apparently, Larry thoroughly researched any new purchase as to the price and quality.] We both had the same Mitsubishi, 36-inch television with the same wood cabinet. We had the same air conditioners, refrigerators, and hot water heaters. They all lasted about 25 years. Carol would come over and ask when we thought the air conditioner would be going out. Because, everything we bought alike would go out about the same time. However, we couldn't find a good lawn mower but, in the later years, Carol did. At one point, Carol said, 'This one's yours,' and six months before she died Carol gave us her lawn mower and hedger."

Larry laughed, "Yes, and that lawn mower starts up every time."

I asked them to describe Carol and Edna.

"Carol was bigger than Edna," Yolanda said. "She was about 5'6 or 7 and, in the summer, she always wore shorts and a tank

top. She was a brunette and kept her hair short and, over the years, her hair became white.

"Edna was about 5'2, with dark hair that later became gray. Her hair was a little longer than Carol's but, like Carol's, Edna's hair became shorter over the years, and neither woman ever colored their hair or wore a speck of makeup.

"Edna was more reserved. She wore slacks and a shirt or blouse. Edna especially liked flannel shirts in the winter. She rarely wore shorts except when she went to the lake."

"Carol was the friendliest of the two, but they kept to themselves. They hated it when they had to call a repairman," Larry said.

Yolanda declared, "Oh yes, Edna was afraid. She would say, 'If he touches me … .' When a repairman came and Carol was not at home, Edna would ask me to be there with her."

I then asked about their neighbor, Judy.

Yolanda said, "Judy is lots of fun. She was always whistling at me. For Halloween, she would dress up like a witch and sit on her front porch and cackle. People dropped off kids in front of Judy's house by the carloads. After she stopped doing it, she had all kinds of costumes, and she would dress Larry and I up, and we would sit on her porch and give out candy."

Larry chuckled, "One Halloween, we were going to a party and Judy dressed me up so well that my long-time friends didn't recognize me.

"On Halloween, Carol and Edna only gave candy to the neighborhood kids. Then, their lights were off, and they didn't answer the door to anyone."

"Carol and Judy had a love-hate relationship," Yolanda added. "They would always complain to us about each other but, underneath, they loved each other."

I asked them to describe Carol and Edna's relationship.

"If they were ever angry with each other, we never knew it. We never ever heard them yell at one another," Yolanda said. "We assumed they were lesbians, but they never showed affection toward one another. They were secretive, but Judy says it was true."

I asked about Eva, and Larry told me they never really knew her.

About Mrs. Sumara, Yolanda said, "She was a pack rat. She never threw anything away. The only way you could walk through her house was along a winding trail between stacks of stuff, and Mrs. Sumara talked your leg off. Any time that she stopped me, I'd be good to get away in an hour. Oh, and she always wore a little house dress."

I then asked about Erma.

Larry took the lead. "She is a handful. She was always fighting with the city, like if she wanted to build a carport, and she complained constantly about anything she could think of, like if a branch was sticking out on a tree.

"Erma didn't mow her grass, she 'manicured' it, and she would do it late in the evening or after dark, because she said

that it was cooler then. Every time Erma mowed, she would sweep the street where her pecan tree had dropped trash, and Erma had a pecan picker."

Yolanda interjected, "I just tried to avoid Erma. As she got older, she got bitchier and bitchier, and she would cuss. She had a mouth. She scared our new neighbors, Lori and Lisa, half to death."

Larry chimed in, "One thing about Erma, she always lets you know where she stands. I don't think she got along with Carol and Edna very well. She didn't talk to them very much, and she got into it with Ralph. He caught her looking in his windows. She wouldn't come to Carol's memorial, because Ralph was coming.

"After Eva died, Ralph bought Eva's house and, when he and Cindy married, they lived there until they bought the house across the street. Ralph is definitely different in the way he puts things. [Much to the concern of many neighbors, Ralph owns five or six rental houses on the block.] He wants a neighborhood where all of the kids can play out front. He and Cindy hand-pick their renters, and most of them have young children, and they play with each other in their front yard."

(Actually, I have enjoyed Ralph and Cindy's renters. They are all very pleasant young people with delightful children. Cindy and Ralph independently told me that they pray before they decide on each new occupant of their rental homes. They

both feel the calling to be spiritual guides and mentors to these young people.)

Yolanda added, "This used to be a neighborhood of older people. We were the first young couple to have a child, and there were no other children on the street when Kevin was growing up. When Judy's daughter, Lisa, came home from school, she was afraid to stay alone, so she would go stay with Carol and Edna until Judy got home from work."

Yolanda and Larry have become close to their neighbors, Lori and Lisa, taking weekend trips to the lake together in the summers.

I frequently see Lori chatting to Yolanda and Larry or Larry helping her and Lisa with a project. I suspect Lori has taken over Judy's role in the neighborhood. She is delightfully friendly and has visited me several times as I have labored in the yard. She and the other neighbors keep cheering me on in my efforts to unearth and restore the flowerbeds.

As we concluded, I commented on a lovely plant that I had been admiring as we talked. Yolanda said that it was a Lamb's Ear given to her by her mother, who is now deceased. She offered me a start and, with delight, I accepted. Now, some of Yolanda's mother's Lamb's Ear is nestled in the bed beneath the cedar tree in Carol and Edna's backyard.

## ~ NINE ~

# Erma

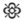

**ONE JUNE DAY,** I was talking to Larry as we stood on our mutual driveways and up rolled an ancient, battered, tan station wagon driven by a disgruntled appearing elder woman. I had just met Erma. Larry introduced me, and Erma promptly proclaimed, "You must be a workaholic the way you are working on that yard."

After her departure, Larry regaled me with a few stories of Erma, and I was suitably impressed by her vigor. Later, Judy told me more about Erma, and I was somewhat intimidated to attempt to interview her. However, Erma made the first move.

In late July, I was setting out the sprinkler in the front yard, and Erma, who lives two doors down, came outside and motioned me over. She was wearing a thin housecoat, and she appeared somewhat distressed and thinner than when I had previously met her. Her hair was done-up in corkscrew curls secured with bobby pins. It had been decades since I had seen hair set in such a fashion.

Erma had just posted a letter, and she asked if the mailman had come.

I replied that I didn't think so.

Erma was concerned that someone might steal her letter. She obviously wanted to talk and asked me to come in, but I was dirty from gardening, so I said that we could sit on her porch steps. She nodded in agreement.

Erma commenced to tell me that she had always been in good health but had recently started falling. She later told me that she had not had a physical for 25 years, and that she never took medicines. She obviously didn't hold much truck with doctors.

"On June 30th, I just wasn't feeling right, so I asked a friend to call an ambulance. When EMSA came, I told those fellows to handle me carefully, because they were dealing with an 86-year-old virgin. They laughed so hard that I thought they were going to pee in their pants."

Erma went on to tell me that she had "bone cancer" and that day and the next she was to receive her last two radiation treatments, which were to be followed by chemotherapy.

During our conversation, Erma asked me for my sign. I responded that I was a Sagittarius. Erma related that she was a Capricorn and, on our subsequent visits, she repeated this fact to me several times. Obviously, for Erma, her sign was an important indicator of her character.

I have had an opportunity to chat with Erma on many occasions throughout the writing of this manuscript, and she is in no way frightening. Her fight is still there, but she seems to

have softened with her illness. Perhaps, for the first time in her life, Erma has had to ask for and depend on others for help.

When I ask about Carol and Edna, Erma remains close-lipped and avoids the topic. Her first statement regarding them still holds, "They were sweet girls, and the secrets of this neighborhood will die with me." Obviously they were and she will.

# Other Neighbors

As I became acquainted with more of Carol and Edna's neighbors, they revealed additional glimpses into the lives of these two women, as well as cameos into their own lives.

## LORI AND LISA

One day while I was gardening, Lori strolled into the backyard and introduced herself and sat down on the grass in front of me and began to talk.

I soon found out that, in July 2002, Lori and Lisa, both in their 30s, had bought the Williams' old house on the other side of Larry and Yolanda's house. When I asked Lori about Carol and Edna, she said that from the time they moved in until the fall of 2003, Edna was still taking evening walks with the use of a walker.

Lori shared that she was very impressed that Edna would always say "Hello" to her Aunt Mary, who lives with Lori and Lisa. Lori described her Aunt Mary as "demented and mentally retarded" and related that each year her Aunt Mary

celebrates the birthdays of her "kitties," Penny Sue and Patsy Ann.

Lori said Carol would sit in a lawn chair in her front yard and weed her flowerbeds and Edna would always sit on their porch, where twice a day Edna would fill the watering bowls and Carol would feed the neighborhood's stray cat population.

Lori said, "Carol and Edna were very special and very private and didn't ask for much, but they were also very independent and stubborn." However, by the time that Lori and Lisa moved to the neighborhood, both women were unable to drive and had to pocket their pride and depend on their friends for rides.

To illustrate her point, Lori told of an incident that began about 4:30 one morning. Edna called because she was unable to reach Tamara and needed a ride to the emergency room. However, on arriving at the hospital, Edna would not allow Lori to stay with her.

I asked Lori why Carol did not accompany Edna to the emergency room. Lori was uncertain but surmised that it was possibly related to Carol's poor health.

On another day, Lori's partner, Lisa, related a similar incident when she took Edna to the hospital. After their arrival at the hospital, Edna tried to pay Lisa for the ride, but Lisa refused. However, at a later date and on some flimsy pretext, Carol slipped Lisa $20.

I urged Lori for other stories about Carol and Edna. She told me that when she and Lisa bought their house, the

previous owner, Brent, asked them to take his older female cat, Trouble. Brent was moving out of state, and he was concerned that the move might be too disturbing for Trouble. Lori said that their house was Trouble's, but she allowed humans to live with her. Lori described Trouble as a big, grey-black, striped cat that liked to crawl up in laps and get her belly rubbed. Lori added that Trouble was everybody's cat and, in their usual independent manner, Carol and Edna insisted Trouble was a male and called her Bernie.

Apparently, Trouble loved to catch crickets and chase stray dogs out of the neighborhood. Unfortunately, Trouble's dog-chasing days ended abruptly. On Mother's Day 2004, Lisa and Lori were called home by the news that Trouble had been killed in Yolanda and Larry's front yard by two roaming pit bulls.

"Lisa and I, along with Carol and Edna, Yolanda and Larry, and Carol and Mark [neighbors from across the street] were inconsolable. Aunt Mary contributed her new ASPCA T-shirt for Trouble's shroud. For some unknown reason that morning, Nancy [who also lives across the street in Judy's mother's previous home] had bought a rosebush that she didn't need. With tears flowing, we all congregated in the garden beside our house and took turns digging Trouble's grave, where she now resides, underneath Nancy's rosebush. After Trouble's death, Lisa and I gave all of the neighbors an open invitation to sit in the garden at any time, because it is Trouble's garden."

Another day, I was at my appointed station, working in the flowerbeds, and Lori invited me in, while her Aunt Mary was away, and asked me to read a psychological assessment performed on her aunt about three years earlier. The report told the story of a young girl, with minimal retardation, that was reared by two alcoholic parents. At an early age, Mary was diagnosed as being "mentally retarded." After that label was hung on Mary, she was not allowed to have friends or go to school. Essentially, Mary became a prisoner in her parents' home. Lori and I went on to discuss how social deprivation would make an even "normal" child appear retarded, and we both felt sad for Mary's neglect. At this juncture, Lori asked if I would like to see her aunt's bedroom. Intrigued, I said, "Yes." On entering, I observed a small, neatly-arranged space occupied by an array of dolls, childhood toys and mementos and, ensconced on Mary's bed, were Penny Sue and Patsy Ann.

On other visits to their home, I was delighted to discover that Lisa is a very accomplished artist and chef and is gifted with profound intuitive insight. Lori and Lisa have been partners for seven years and, during my many conversations with them, I have had the opportunity to observe how openly comfortable they are with each other. On discussing Carol and Edna's secrecy regarding the nature of their relationship, Lori reminded me that, in the not-too-distant past and too frequently in the present, individuals were or are killed for being openly gay.

## RALPH AND CINDY

In 1976, Ralph bought Eva's house, and he later married the realtor, Cindy, who sold him the house. Eventually, Ralph and Cindy bought the house across the street, in which they currently reside, and they now rent Eva's old house to Hollie and her three-year-old daughter, Maya.

Ralph is frequently in his or Hollie's front yard, so we have had several opportunities to chat. Ralph told me that he lived most of his life in Arkansas, and he describes himself as a "salesman," who has owned several businesses.

Currently, Ralph, now in his early 60s, has a part-time job working at a truck weigh-in station, starting at six in the morning. Ralph tells me that he finishes his workday before most people have decided what they want for lunch.

One can't talk with Ralph long before discovering that he is in love with his wife. One summer afternoon, Ralph was singing her praises to high heaven and said, "Cindy is a Proverbs 31 kind of woman. She gets up before I do and often goes to bed after I do. She sells several million dollars worth of real estate a year, is an active grandmother, and is teaching Vacation Bible School this week."

Cindy is a thin, highly energetic woman, with red hair and freckles, who shines with admiration for her husband. One day as Cindy and I talked on her front lawn, she said, "Ralph is an exhorter. He holds people up. He praises them.

When I first met him, he called me 'Baby Doll.' I didn't know what to make of it, so I asked my pastor, 'What do you think he means by that? Is this guy really as good of a man as he seems?'"

Cindy's pastor assured her that Ralph was the real deal and said, "As to 'Baby Doll,' only Ralph knows what he means by that."

Cindy added, "When something is troubling Ralph, he journals. I have stacks and stacks of his journals. When I feel down, I read his journals and receive comfort. If he should go before I do, those journals will be important to me."

Cindy's only child, Amie, and Amie's two young daughters, Emma and Courtney, live next door to Cindy and Ralph and across the street from Carol and Edna's. Cindy told me that she raised Amie by herself and that for years they lived in an apartment above Cindy's real estate office. Cindy also said that Ralph gave her the greatest gift he could possibly give her when he bought the house next door and moved in her daughter and granddaughters.

Ralph and Cindy have told me on numerous occasions that they just loved Ms. Carol and wanted to buy her house after she died, but they had prayed about it and realized it was to go to someone else, and they both have shared their delight in my purchase of the home.

One day I was finally able to corner Ralph for more extensive questioning, and he filled me in on the neighborhood.

Ralph held forth, "Miss Eva was the street's matriarch. She occupied her home from 1931 to 1994, and all these women looked up to her, (meaning Carol, Edna, Erma, and Erma's sister, Dorothy). Miss Eva was a spinster schoolteacher and Baptist Sunday school teacher. She had no pets, and a man never walked into her house."

I asked Ralph about Carol.

"Miss Carol was a wonderful, beautiful, polite, kind, concerned, non-intrusive servant, and she loved her yard, flowers, and cats. She mowed up to four or five yards every week, including Miss Eva's. She also walked to the 'Water Works' each morning and afternoon (a two-mile round trip).

"Miss Carol was bold and courageous enough to ask for what she needed. One day her blood pressure was 240/140, and she asked me to take her to the hospital. I went by to check on her three times that day. Each time I went by, she'd say, 'Ralph, you've got to get me out of here. If you don't, I'll die.' I took her home."

As tears streamed down his face, Ralph said, "Two days later she was out there working in her garden. She kept on trucking and never missed a beat. She knew where life was for her."

I then asked Ralph to describe Edna.

"Miss Edna was like a drill sergeant. She barked. She'd say, 'Ralph, come over here. Ralph do this. Ralph do that.'"

Next, I asked about Erma.

"If Miss Edna was a sergeant, Miss Erma was a general foreman. She didn't bark much, but she was one of the most unique personalities I have ever known. She was Dutch, and she and her sister used to scream and yell. I could sit in my house and hear them.

"They knew Miss Erma in City Hall and at the governor's office. The state representatives and the city councilmen all knew her. If you were an authority figure in the city, you knew Erma. She gave them all hell.

"Erma never had a TV or listened to a radio. She'd peek in your windows to see what you were doing. Once she called Judy and told her that a man was running around naked inside the house next to Judy's. Judy asked her how she knew, and Erma said that she could see him with her binoculars. Judy told Erma to put away her binoculars.

"I got where I couldn't deal with Erma, so I had to start calling the cops. I called them on her three times. Once she scalped my yard. Another time she drove her car across my front yard and nearly scared Cindy to death. Cindy thought she was going to ram it into our house.

"It got so bad Judy talked to Erma and told her if she didn't quit acting so crazy that they were going to lock her up."

Well, to say the least, Ralph has had a lively time with his neighbors.

## HOLLIE

Hollie and Maya moved into Eva's old house on July 1, 2005, just after Edna's death and shortly before Carol's. Hollie related to me that each morning as she left to take Maya to daycare and then go on to work that she would see Carol sitting on the front porch throwing bread crumbs into the yard to the hundreds of birds that flocked to feed at her table. (I suspect the cats had a different feeding schedule.)

Hollie said that a few weeks after she moved in that Carol was sitting in a chair in her front yard and pulling weeds out of her flowerbeds. To strike up a friendship, Hollie walked over and told Carol that her beds looked nice. Hollie said, "Carol promptly replied, 'They look like crap.'" (And by the meticulous gardener Carol's standards, they did.) Because of Carol's response, Hollie said that she immediately liked her.

## CARL AND MARK

Carl and Mark have lived three doors down and across the street from Carol and Edna's for 13 years. They related that when Judy sold her house, she would back her car into Carol and Edna's driveway and watch the goings on.

Carl and Mark are the neighborhood tree planters. Immediately on my meeting them, Mark asked me if they could plant an elm tree in my yard. I am holding off on my decision to get a better feel for the yard. Ralph once told me that he had

cut down a fairly large scrub tree in his backyard, and Mark told him that he had "killed Mother Nature." Ralph clutched his heart, indicating the wound inflicted upon him by Mark's words.

## JUNGLE GEORGE

George was born in 1926 and has lived on Carol and Edna's block for 30 years. Although George did not know the women well, George is my gardening guru.

For many years, George was a university horticulture teacher. True to his calling, George's yard is a jumbled profusion of plants of all descriptions, hence the source of the name with which he first introduced himself to me, "Jungle George."

George's mind is a treasure trove of information and, as we survey his yard together, George rattles off each plant's scientific name, growing habits, and care.

Following his teaching career, George was happily the head horticulturist of a nearby university's grounds for many years until the university presidential position was filled by a "Yes Man." George said this president made the college a lot of money, but I gather the president and George butted heads because, as George said, "I wasn't a yes man."

On the university grounds crew, George often hired members of one of the fraternities and, since his departure from the university, the young men work for George on private landscape commissions or at his home. George proudly states

that he taught work ethics to those "pampered boys." George's motto to his charges was, "asses and elbows—hit it." To show their appreciation for George's lessons, the fraternity members bought George his current car.

For many years, George was the president of the Oklahoma City Horticulture Society, and he continues to be a board member. Apparently, one woman on the board wanted George to step down to let in "new blood," but other board members encouraged him to stay by saying, "George, you're our rock, and you'll speak up for what's right." George's response to his disapproving board member was, "If I have to crawl, I'll be at the board meetings. You can count on that, sister."

Many sprouted seeds and starter plants from George's yard now occupy Carol's flowerbeds.

After glimpses of Carol and Edna through the eyes of their colorful neighbors, we next turn to the two that knew them best, Tamara and Rhonda.

# Tamara

**TAMARA IS THE EXECUTOR** of Carol's and Edna's estates, a veterinarian, the mother of 7-year-old Tristan and 4-year-old Dimitri, and the wife of Tim. Needless to say, Tamara's time is a premium commodity. However, on a cool, rainy day in early September, I seized a window of opportunity when Tamara was home recuperating from surgery.

Tamara and her family live on an acreage in the rural outreaches of Oklahoma City. As I parked in front of their gated yard, I was greeted by three barking, but friendly, dogs. I was uncertain how to proceed, but Tim came to rescue me from my canine greeters and, with great kindness, Tamara, Tim, and the boys welcomed me into their very pleasant and spacious home that was obviously inhabited by busy boys and two child-sensitive parents.

As Tim occupied the boys, Tamara and I settled into the couple's bedroom, where I found a comfortable armchair and she rested on the bed. Beside her was a large, pink plastic box, containing Edna's photographs and memorabilia.

During earlier phone conversations, Tamara had told me that her sister, Rhonda, rented the house across the street from Edna and Carol in 1986 and, after Tamara finished veterinary school in 1988, she moved in with her sister. They each lived there about eight years.

Tamara began, "Until about five years ago, when Rhonda decided she liked men, she had female partners, and that was why Rhonda, Carol, and Edna were so close. Because Rhonda was gay, we built a trust factor with Edna and Carol, so they talked openly to us. So, of course, we knew they were gay.

"After Rhonda moved away from Carol and Edna's neighborhood, she talked to them every day, and we both participated in taking them shopping and to doctor's appointments. Edna called Rhonda her 'buddy.' After I moved, I talked to them three or four times a week. Edna was my friend. I could talk to her about absolutely anything. I never held back with her."

Tamara picked up papers from the box that pertained to Edna's funeral.

"For about seven years, until I had Tristan, Rhonda and I, along with our friends Louise and Ginger, sang in a group that we called 'Freefall.' All of our group attended Edna's funeral and graveside service. We performed several songs, including 'Amazing Grace' and 'He's Got the Whole World in His Hands.' Carol was very glad we sang. She said that Edna would have appreciated it."

Tamara explained, "When our group performed, we often took Edna, and she loved it. We'd invite Carol, but she wouldn't go. For Edna, it was a way to get out of the house. Things were not always easy between them in those later years. However, any animosity that happened between them, came and went. Overall, they were committed to each other. They were together in a relationship in a time when it was not acceptable to be gay, so there was a secret, and that secret bonded them together for 45 years. However, at times, they got sick of each other and needed some time apart.

"I wonder what it was like being gay at a time that it was looked down upon?

"Rhonda and I were very, very close to Edna. She was easy to get to know and love. Edna was gregarious and outgoing and enjoyed interacting with all kinds of people. Edna described her homosexuality as 'running with the girls.' Although Edna never told her family of her sexual preference, she loved being out in the gay community. When Rhonda and I took her to concerts, everybody would fuss over her. Carol wouldn't allow herself to participate, so she received her pleasure vicariously through Edna.

"Edna had a sweet, bubbling personality. She loved to laugh and to be touched, and I always gave her a hug when I came and when I left. It was natural to love on Edna. She ate it up.

"Carol, however, didn't like to be touched and would almost recoil if I tried to hug her. She kept a physical space around

her that was pretty big. I sensed that maybe she was afraid of getting too close or loving too much. Her distance always made me sad. I was determined to have some physical contact with her, because I was convinced she desperately needed it. So, I approached her like I would a frightened animal. Eventually, we had an unspoken agreement that I would not try to hug her. I could touch her on the knee or shoulder, with two fingers, for a few seconds, and she would not flinch and appeared relaxed. That felt like an accomplishment.

"In their later years, my impression from Edna was that Carol wouldn't be affectionate with her, and Edna missed it. When I talked to Carol about it, she said that after Edna strained her back and had to wear a brace for awhile, that Edna didn't want to be intimate anymore. I never saw them be openly affectionate and, as the years passed, they became more like housemates than lovers.

"Carol was very gruff, and she could be taciturn. Sometimes Edna would say, 'She won't talk to me, Tammy.' Tammy was Edna's name for me. Those times were hard for Edna. When I asked Carol questions, she wouldn't necessarily explain things in any depth. Carol was angry a lot of the time, but she could cut up, too. We had some amazing times together last summer after Edna's death. She would tell jokes and cackle.

"Once I heard Carol make a comment about how Edna dressed in boys' clothes. Keeping up appearances was important to Carol. So, I think she was critical of how Edna chose to

**Edna and her changing dress code.**

dress. In later years, I don't think Carol cared so much. I never saw Carol in anything but shorts and tank tops, even in the winter, because they kept the house so warm for Edna.

"Carol didn't want anyone, who was not gay friendly, to know that she was gay. Until the day she died, she didn't want Judy to know. Carol was afraid that Judy would tell all the neighbors. Carol took privacy to the extreme. Of course, Judy had figured it out a number of years ago and was probably

openly accepting. [Obviously, in my interview with Judy, mum was the word regarding Carol and Edna's sexual preferences. In my presence, their secret did not pass her lips.]

"After Edna died, Carol went through a cathartic period, and she wanted to talk, and I discovered things about her that I had never known. During this period, Carol wanted to record her story but, before we could get it scheduled, she backed out." (On that Sunday afternoon as I worked in the garden [see Preface], I sensed that Carol, now residing safely on the other side, was finally able to be free of her secret and had requested me to tell her story.)

Tamara interjected, "I often wondered if something had happened to Edna, like incest or rape, and Jan thought that maybe Carol had been raped.

"It seems in the gay community that many women have had events in their lives that made them angry toward men, so they turned to women. Then, there are other women who, at an early age, had a sense that they were gay. Influenced by childhood sexual abuse by our father, Rhonda turned to women in her sexual relationships. She thought being with women would solve her problems. But, she found that the relationship issues were the same with women as with men, there was just no penis or testosterone involved."

Changing gears, Tamara said, "With Carol, everything was done a certain way. We were in deep do-do if we were late with a birthday or Christmas card. Carol was the caretaker during

the time we knew them. She cooked and took care of the house and the yard. I once asked Carol why she didn't learn to drive. She replied, 'Because Edna didn't want me to.'

"Edna was very much a tomboy. She loved and was good with tools, and she worked at a factory that made tools. Edna gave Rhonda and me practical and handy tools as gifts. Edna was the one who built and repaired things around the house until her later years. The workshop attached to the garage was Edna's. [I stood corrected. Since Carol was the yard person, I had assumed that the shop was hers.] In fact, shortly after Rhonda moved into the house across the street, her car tag was dangling by one screw. It was driving Edna crazy. Rhonda's friendship with Edna started when one day Edna came over and introduced herself and fixed Rhonda's license plate."

Turning back to the subject of Carol, Tamara said, "Carol was adopted when she was eight months old. A mother has already bonded with her child at eight months, so I assume Carol's parents were poor, and here was this rich family that couldn't have children. Carol's brother was also adopted. Interestingly enough, Carol had nice dishes, but she chose to eat off plastic and with plastic utensils. I think it was all tied up in self-worth, not feeling good enough. Maybe because she was adopted and felt thrown away be her parents.

"Carol was raised as a little frou-frou girl, and she had a degree in music. The piano thing was her mother's idea. Carol even taught piano for awhile. Then there came a point in her

life that she broke through her family's expectations. One day she set the table very nicely for dinner, and she announced that she was joining the Marine Corps. Her parents were less than thrilled."

Tamara added, "Carol's brother committed suicide when he was in his 30s. His parents were in denial and also wanted to keep up appearances so they told everyone that he had 'heart trouble.'"

I asked Tamara if she knew how Carol and Edna met.

"Carol was living in Ohio, and a mutual friend told her about Edna, so they started communicating by letter. In 1960, Carol came to visit Edna in Oklahoma City, and they hit it off. Carol only went back to Ohio to give notice at her job. Then, she moved into Edna's house."

As Tamara and I looked through Edna's box, we found numerous photographs of cats that occupied Carol and Edna's home and laps. We also found an album that Edna had filled with note cards and postcards adorned with wide-eyed, fluffy kittens and an occasional puppy. Often the postcards were sent by Carol on her annual trip to Florida and were addressed to Edna and whatever cat or dog that was currently in residence. Among the cards was one titled "With Love on Our Anniversary" and signed "Carol and Corkey." Tamara informed me that Corkey was their dog.

Tamara smiled and said, "Carol and Edna loved animals. They would even give gifts from their animals. They had a

cat, Mickey Lee, that I gave them. I had a cat that I named 'Bee-Kitty,' that Edna called 'Boo.' Rhonda had a Pomeranian that we called 'Zevie,' that Edna called 'Little Wart.' [Obviously, Edna decorated various animals with her personal handle.]

"Carol and Edna lived very frugally, and their needs were very little. They chose to do very little for themselves, yet, both would be very generous, and Carol was generous to a fault. They took on my family, and they would lavish presents on us at Christmas and on birthdays.

"Carol also donated money to the Salvation Army, to Habitat for Humanity, and to local animal rescue organizations. She could not stand to see anything hungry. For years, she fed all of the stray cats in the neighborhood. Sometimes she would give me bags and bags of food to pass on to rescue groups."

At this point, Tamara and I discussed the possible origins of Carol's behaviors, which included the fact that even at eight months of age, an infant is aware of and subconsciously stores the memory of physical and emotional deprivation and hunger.

"Once, Carol and I undertook the task to create a sterile feral cat population that numbered out about 15. I supplied Carol with the cages, and she trapped them with food, and I would spay and neuter them. We then turned them back out into the community, and Carol continued to feed them."

Also in our photographic review of Carol and Edna's life together, Tamara and I discussed the evolution of their home's

interior. In their earlier years, the windows transmitted light through sheer curtains. There were glistening hardwood floors, and the walls were painted light colors. This airy and open feeling of the home contrasted to the interior's appearance at the time of their deaths. The floors were covered with ancient carpets, and the walls and ceilings were covered with thin, dark paneling. Tamara said, "The paneling was Carol's idea, to make it easier to keep." Also, the windows' ability to transmit light was null and void. They were covered by black, iron bars and heavy draperies. Tamara and I surmised that perhaps as Carol and Edna grew older, they felt vulnerable and unable to protect themselves, so they closed off and isolated their environment to feel safe.

Moving to another topic, Tamara said, "Edna was a voracious reader. She would read every single night. When Rhonda and I loved a book, fiction or non-fiction, we'd lend it to her or buy her a copy. Edna was always very cheerful, until the last two years of her life, when her eyesight really began to deteriorate. She had glaucoma. In those last years, Rhonda and I went to the library or bookstore and got her books with large print. Later, we got her books on tape, which she listened to every night.

"After they both had died, I was going through Edna's things and found a couple of old lesbian books. They were early writings, when women talked about loving women, but didn't let anything happen. I suspect those books affirmed to Edna that other people had the same feelings for women that she did."

Changing topics, Tamara said, "Carol and Edna were the community's watch dogs. Edna sat in a chair behind the front door. They watched television, kept the door open, and watched the neighborhood. Our house was right across the street from theirs. Edna could recount times, colors, and events of the comings and goings at our house. She had an amazing mind for detail. She never had a bit of senility.

"Carol had a number of really difficult physical ailments. She had survived lung cancer but, as a result of her radiation treatments, her esophagus had a stricture. She had it stretched two times, but Carol hated doctors. She would have one- and two-day periods when nothing would go up or down, not even saliva. I think she was afraid that she was going to die before Edna. She didn't want Edna to find her dead. When she laid down, her lungs would become congested, so, for years, she slept sitting up. She would sleep one or two hours. Then, she would awaken and watch television for awhile, then sleep a little more. As a result, Carol was in constant sleep deprivation. I am sure that this contributed to her overall manner with people. She was in a survival mode. She was determined to stay alive in order to take care of Edna.

"In addition, Carol also had pins and wires in her foot, and she was completely blind in one eye, and that eye was clouded over. However, Carol was very observant with that other eye."

Turning back to Edna, Tamara said, "Edna and her sister, Dot, were very close. They spoke every day, and they enjoyed going fishing together."

Tamara remarked, "Edna was not close to her twin. Apparently, Edna was very angry with Ethel for going off with that man [her first husband]. She felt betrayed. I suspect until then, she and Ethel were very close. However, Edna was very close to her nephew, Archie, Ethel's only child, who she helped raise."

When Rhonda moved to Denver in March of 2005, she arranged for friends in the gay community to check on Carol and Edna.

"On the very day that Edna died, the television that they had for years stopped working. Carol didn't want to get a new television. She felt Edna's energy had stopped the television. Also, within one to two weeks of Edna's death, cardinals came on the porch. Edna loved cardinals, and they had never come down to the porch before. Carol felt very strongly that the cardinals were Edna. To honor Edna's love of cardinals, Carol ordered them to be put on her headstone. A few weeks later, the cardinals stopped coming to the porch. Then, Carol felt that it was OK for her to have a new television. So, she and I went and bought her a big, wide-screen television. Carol wished that she had bought a new TV before Edna died, because she thought Edna could have seen the big screen better than the old one. Carol died two weeks later.

"After Edna died, our friend, Margaret, who was retired, had a key to Carol's house, and helped check on her. One day, Carol did not answer her phone. Margaret went over and found her dead."

I asked about Carol's memorial on the front lawn.

"My goal for the memorial was to have people share their memories. Carol did not want a church thing or a big to-do. It was very sweet. I was very touched by people coming forth and saying things."

When Tamara went to Florida, she met Jan, Carol's long-time friend.

"Jan was very candid and, as we looked for the right place to spread Carol's ashes, we walked and talked on the beach for three hours. I felt that I could discuss almost anything with Jan. When we located the spot that felt right, we made a shrine with some beautiful flowers and scattered her ashes. However, I held back some of the ashes. I needed a private ceremony for myself.

"Carol loved animals, especially birds. Later that day, in a private ceremony, I collected seashells, mixed with sand and Carol's ashes, and created a memorial on the beach. The next day, when I returned to the beach, there were little bird footprints that circled around the seashells. It seemed that knowing the significance, the bird hadn't disturbed the memorial. I brought a small handful of sand, mixed with her ashes, to put in her garden. Carol loved the beach. She loved her garden, and she loved Edna."

❀ ❀ ❀

After Tamara and I had exhausted ourselves by talking and pouring over Edna's treasure box, Tim graciously invited me to lunch, which he had prepared while tending the boys and installing a ceiling fan.

After lunch, Tim and I got acquainted while Tamara attempted to find photographs of Carol that were stored in cyberspace. Tim also brought up books found in Edna's belongings. He decribed them as "early gay fiction," containing "painful, deferred longing … nothing physical … just the acknowledgement of the sorrow of perpetual, unfulfilled longing."

Tim and I also discussed writing and the novel he was working on. Tim is also a poet and has a Ph.D. in English. From my observations, Tim and Tamara are well-suited. They both are sensitive and caring individuals, who also happen to be very articulate, highly intelligent, and well educated.

Among Edna's things, Tamara and I found an aged newspaper clipping of unknown date and origins. I suspect it mirrored Edna's philosophy on life.

### PORTRAITS

*By James J. Metcalfe*

If you can find some happiness … Wherever it may be …
Enjoy it to the utmost with … Your heart and energy …
For nothing is more wonderful … In life from day to

day … And nothing else can do so much … To put your fears away … However small that joy may be … Hold on to it real tight … Including every rainbow while … It still remains in sight … Wherever there is happiness … There is no time to cry … To wander off in loneliness … Or sit around and sigh … So try to find some happiness … Wherever you may go … And little, if at all, will be … The trouble that you know.

From Edna's photographs, it is clear that Carol and Edna found happiness throughout much of their lives together, even if that happiness was most often shared in secret, behind closed doors.

**Carol and Edna—A Private Birthday Party.**

**Edna and Carol—Home's Safe Haven.**

# Rhonda

RHONDA IS TAMARA'S SISTER, who currently resides in Colorado. Actually, Rhonda and Tamara, along with their other six siblings, were reared in rural Colorado.

Before my meeting with Rhonda, Tamara had loaned me a book, *Breathless*, written by her sister, Victoria, which describes the sisters' childhoods. Victoria writes that their mother was a "shy piano teacher with a Bachelor's of Arts in music and a creative touch for everything she laid her hand to," and their father was a "nuclear physicist, an outdoorsman, a rock climber, a mechanic, a carpenter, and an active community leader." 6

Victoria describes their childhood in the beautiful setting of the Rocky Mountains. She tells of the family's "self-sufficient lifestyle," in which her parents designed and built their home on a "shoestring" and, like their neighbors, they "possessed more creativity than financial resources." Victoria relates that, besides birthing and rearing eight children, their mother was busy either building, teaching piano, gardening, canning, baking bread, or sewing. 7

Victoria further relates that their mother "never spent more than twenty dollars a week on store-bought groceries" and, at the local meat locker, their parents stored frozen venison and fish gleaned from their father's hunting and fishing expeditions, plus meat from their own chickens, rabbits, and goats. The family had milk, butter, and cheese from their goats and eggs from their chickens. In the summer, they ate fresh vegetables from their garden and, in the winter, they ate their home-canned goods, which included tomatoes, pickles, and juicy Colorado peaches. Besides being nourished by the Earth's bounty, their mother believed in natural remedies and, when the children were sick, she took them to the chiropractor or to Hannah, the local herbalist, who also ran the health food store.[8]

Victoria added that the sisters' seemingly idyllic childhoods were marred by the fact that their father was "a pedophile who sexually abused all of his children from the moment they were brought home from the hospital."[9] In her interview, Tamara, the youngest child, described her father as a "very, very bright man, but he was crazy, too."

With this backdrop, I met Rhonda, who was in Oklahoma City visiting Tamara.

Rhonda was born in 1953 and describes herself as "a very busy person. I am always on the go," and I knew that to be true, because it had been difficult for Rhonda to work our meeting into her seemingly hurried, two-week vacation schedule.

Rhonda told me about her first meeting with Edna. "She was in her early 70s. She had a screw and bolt in one hand and, in the other, she had a screwdriver. She said, 'I'm Edna, and I'm going to fix your license plate. It is hanging on by a thread.'"

Rhonda added, "I was with women for 18 years, so I had my 'gaydar' up, as they say, and I suspected right away that Carol and Edna were gay.

"I met Carol a few days later. Edna invited me into their home, but Carol wouldn't come out of the kitchen. She just sat on a stool in the kitchen. Edna said, 'Carol, come meet Rhonda.' Carol replied, 'Oh, that's OK.' Most people would have interpreted Carol's behavior as excessively rude. I wasn't put off. I am always intrigued by people's stories. It took Carol many more weeks to leave the safety of the kitchen and come into the living room. Then, she would trundle back into the kitchen."

Rhonda added, "Carol could be very, very critical. There were certain rules of etiquette that you had to follow, or you were out of her good graces, and it would take you a long time to regain your former status. So, my friendship was mainly with Edna. However, the first Christmas after we had met them, they gave us an excessive amount of gifts. I got the impression that Carol was so grateful that I was Edna's friend.

"I took Edna to all kinds of events, like concerts and when my partner, Louise, and I got married. I would ask Edna to

**The Bicycle—Carol's Work Transportation.**

invite Carol, but Edna would tell me, 'Carol doesn't want to go.' In retrospect, I believe Edna didn't ask Carol but wanted to keep me all to herself. I don't think less of Edna for it. It was just an interesting dynamic. But, when Edna died, it was like the opening of floodgates, and Carol began to talk. I learned that Carol was hurt that I didn't invite her, and it was very painful for me to find out how much Carol hurt.

"However, I do believe Carol protected my friendship with Edna and did things to preserve it. For example, Carol was the one that loved cats, and Edna would tell Carol, 'The cats are always your cats; they never love on me.'

"So, with their cat, Mickey Lee, Carol would have no truck with that cat, and she would push it away. So, Mickey Lee was Edna's cat.

"Carol engineered it to her own determent. Likewise, I believe Carol engineered her coldness to me."

Rhonda continued, "Carol was a beautiful woman, but she aged into bitterness, which I believe was due to the failings of her body and to the loss of all of their friends. Carol was a shy person and deeply, deeply lonely. In their earlier years,

**Edna and her cat.**

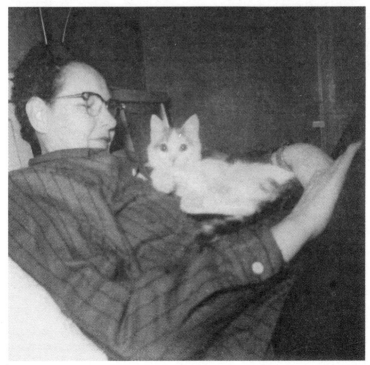

Carol and Edna were partiers and had a little group of women friends with whom they smoked and drank and played cards or went to the lake. They called their friends 'the girls.' This is conjecture on my part but, as their women friends died or moved away, Carol's shyness took over, and for her to open up to a whole new community was too terrifying for her to contemplate."

Returning to Edna, Rhonda said, "In our conversations, Edna and I fluttered along the surface. We shot the shit. We didn't go into any depth. Edna would use me as a sounding board in her frustrations with Carol and Carol's anger."

Rhonda elaborated on the differences between Carol and Edna.

"Edna came from a rural, sticks background, and Carol was educated and came from a background of privilege. Edna's family was dirt poor, and she had to work as a child. Because she worked in the sun truck farming, Edna had many skin cancers. I got the impression that Edna didn't quit school because she wanted to, but because she had to. Edna told me that, at six or seven, she loved to crawl up in a tree in their backyard, sit on a big branch and, for hours, crow like a rooster. Edna said that her mother would finally come out and say, 'Edna, stop that racket.' I laughed and laughed when she told me that story.

"I also got the impression from Edna that, when she was young, there was violence in her life. What that generation would have called being 'very strict.'"

Along the same vein, Rhonda said, "Because of Carol's social behaviors, which were very extreme in my opinion, I assumed something very terrible had happened to her. I can hear her say, 'Yeah, isn't that just like a man,' with a fair amount of charge to the statement. But, what Carol lacked in her generosity with her social interactions, she compensated for by her very generous gift-giving. Every time I took Edna to Dot's, Carol would load the car with a huge amount of stuff, including groceries. Also, when my church had a food drive, Carol would go out and spend hundreds of dollars, and Carol's contribution would equal as much as one-fifth the contribution of the entire church.

"Carol walled herself off in her anger, and I felt that she was emotionally starving the whole time that I knew her. I believe Carol only began to accept me in the last three years, when I frequently took her or Edna to their doctors' appointments and, near the end, Carol would actually sit on the couch in the living room and shoot the breeze with Edna and me.

"However, in those few days after Edna's death, Carol opened up and told me things in her heart, more than Edna had ever told me. It was during this time that she told me what she had done for Edna with Mickey Lee. Carol also shared her resentment toward Edna, including her not getting to come along to things, but my impression was that the angry words were really about being left behind after Edna's death."

I asked, "Did Edna ever tell you when she knew that she was gay?"

"Edna knew she was gay in her preteen or teenage years. However, she did date a guy [ Joe] that loved her and wanted to marry her.

"Edna and her identical twin, Ethel, had a terrible falling out when they were 15, and Ethel ran off and got married. Edna never forgave her. Maybe there were actual conversations between them about their feelings for other girls, and Ethel bailed out."

I then asked if Rhonda knew how Edna and Carol met and developed their friendships with other lesbian women and couples.

"It happened at work. Working in a factory environment, building things, women of that generation found each other out of sheer desperation. With 'gaydar,' that sense of knowing, you find each other. There were no clubs back then. I often think of rural women during that period. They had no frame of reference for who they really were. They lived a lie.

"Edna and Carol were very secretive about their gay lifestyle. Carol was socially homophobic, and Edna protected her family and Carol. Besides in Carol and Edna's generation, you didn't talk about homosexuality. You didn't even talk about sex."

Rhonda added, "I know that Carol and Edna had not been intimate for many, many years. Edna would say, 'She won't touch me, not even hug me. I still feel things. Just because

you are old doesn't mean you don't feel things. Believe me, I know.'"

Briefly, Rhonda shared about her life.

"After many years with women, I stopped wanting to be sexual with them. I wanted to be sexual with men, and I am now exploring all of that. But, damn those screwy men. Over and over, I am slammed with the realization that men are not like women in their emotional commitment, the whole she-bang. Men are just not like women."

Agreeing, I laughed and commented on the impact of testosterone on the masculine brain and its wiring system.

Returning to Carol, Rhonda said, "One source of Carol's anger was her terrible sense of betrayal by her body. She had a racking, painful cough, and her foot hurt so much that it was miserable for her to wear shoes. It was hard for her to take. Carol had been a very active and capable woman. It was unbearable for her that she couldn't work in her yard or even change a light bulb."

After Edna died, Rhonda went with Dot to the funeral home and sat with her and Edna's body.

"Dot said over and over, 'I can't get over how good and how natural she looks.' Dot kept her emotions in check. I was glad when she left. I was in there another three hours, crying. I know it is absurd, but I felt like I killed Edna. I moved away. I took that stupid job in Denver. I came back every month, for Edna. I know it is not true. Who can know what one's

process is in leaving the world? Edna's twin had died a few months earlier." Then, with tears in her eyes, Rhonda said, "I spent a lot of time in that funeral room, apologizing to Edna for abandoning her.

"Our group, Freefall, sang at Edna's funeral. Edna loved Freefall. Edna said to me, 'It just tickles me that you all would fool around with an old lady like me. You are so important and interesting.' There were several members of Edna's family at the funeral. I wonder if they knew that there was quite a large contingency of lesbians there?

"Carol was very moved by the funeral, and she was so pleased that we sang and did happy songs, not funeral dirges. Carol said, 'I just know that Edna sat right up in her grave and clapped for those songs.' It made Carol so happy for Edna's funeral to be a joyous thing.

"Carol was utterly and completely devastated about Edna's death. Before I returned to Colorado, Carol hurt so much that she said to me, 'Now, I understand why people contemplate suicide.' When she died, that was it for Carol. Carol would have died sooner if it wasn't for Edna. When Edna died, Carol could too. She didn't have to take care of Edna anymore.

"After the funeral, I drove back home to Denver. In my mind, I was laughing, talking, and singing with Edna the entire time, and I felt happy. I didn't cry. I had cried a lot before I left. The minute I got home, I fell apart. I felt strongly that Edna

was with me on that trip to get me home safely. Otherwise, it would have been dangerous for me to drive.

"After Edna died, I called Carol every day for awhile. Then, three or four times a week. Margaret, a retired friend in the gay community, called Carol every day to check on her. Carol told me that Margaret's phone calls were driving her nuts. I was so wistful for the close conversations that Carol and Tamara had in those last two months. Conversations that we couldn't have on the telephone. I thought, 'Oh my God! All those lost years.'"

Next, Rhonda told me about Carol's memorial.

"We all gathered in Carol and Edna's front yard, but I did not feel Carol's presence in the circle. I felt she was gone, that she had moved on. I sensed that she was finally rid of that body and had embraced the joy and freedom on the next plane."

Rhonda concluded, "Back in Denver, I try to explain to people about my relationship with Edna. I tell them that she wasn't a mother figure, and she wasn't a grandmother figure. It was more like she was a sister. I know it is an odd thing to say, with our degree of age difference, but I almost felt like I was her older sister."

# ~ THIRTEEN ~

# Pat

TAMARA HAD GIVEN ME Pat's and Margaret's names, because both women had known Carol and Edna in the last few years of their lives. Tamara had also related that both women were active in the local gay community and might help me gain insight into gay and lesbian issues, particularly the emotional impact of being gay in the early and mid-20th century.

Pat arrived to our meeting wearing a pair of jeans and a blue-plaid, flannel shirt and driving a silver, Mini-Cooper convertible. As I listened to Pat's soft, gentle voice and observed the kindness in her face, I knew that she was a good and loving soul.

Pat was born in 1954 and teaches computer networking in an Oklahoma City university. She said that she knew that she was gay when she was in her early 20s and added that she had no history of sexual abuse.

Pat was with her first partner for 13 years, and she and her current partner, Jean, have been together for 17 years.

I asked Pat to describe Jean.

"Jean was born in 1946 and is pretty laid back. She is a social worker, by training, but works as a clinic coordinator for a health center."

I next asked Pat what she enjoyed about her relationship with Jean.

"Our friendship is the most valuable thing. We were friends before we were partners. I also enjoy the dependability of our relationship. It has the security and comfort of an old shoe. I am past the need for excitement and flashiness." Pat went on to share that she and Jean had two dogs and four cats and that they both enjoyed bicycling, and together they had taken many extended bicycling excursions.

I asked her how they met.

"We were both involved in Herland, which was formed in the early 1980s. Herland is a local, nonprofit, women's organization, which I describe as a lesbian community center."

Turning her thoughts to Carol and Edna, Pat said, "Jean and I met Edna in relationship to Herland-sponsored music events. Rhonda was always calling and asking for someone to give Edna a ride. Edna was so gregarious and, wherever Edna went, she was the center of attention.

"I had been around Edna off and on for several years and had never met Carol. Until, one day Edna was having outpatient surgery, and I went to be with her and Tamara. When I got there, Carol was in the waiting room, and she was not friendly. Edna was still waiting to have her surgery, and Tamara was preparing to take Carol home. It was my sense that, out of concern for Carol's health, Edna did not want Carol to stay. Of the two, Edna always seemed to be in better health. From

Tamara's comments, it seemed that Carol could kick-off at any time. Edna seemed to be the Ever-Ready bunny. She was definitely somebody that you couldn't ever stop. However, for Carol to be there with Edna during her surgery meant a public acknowledgement that they were partners, and the secrecy that they maintained about the nature of their relationship was at an amazing level. I sense that was part of the reason that Carol never attended the Herland events.

"I did not have a relationship with Carol until Edna passed away. I got involved to be helpful to Tamara, Rhonda, and Margaret. Carol was definitely a gruff woman, but it was clear that she appreciated people's involvement with her and Edna. After Edna's funeral service, Carol took us out to eat barbecue at Edna's favorite place. Carol said that dinner was 'on Edna.' It felt like our going to dinner with Carol was important to her, but Carol didn't hardly talk at all.

"After Edna passed, Carol came to our house to meet a friend of ours, Sandy, who is an estate attorney. Carol wanted to get her affairs in order. Carol did not want Sandy to come to her house. I gathered it was a privacy or secrecy issue. Carol was not somebody that made it easy to do things for her but, after Edna died, she needed people to do things for her. The second time that Sandy and Carol met at our house, Carol brought Jean and I a gift of a large, crystal bowl. It was an odd juxtaposition. Carol was grumpy and could not give of herself but, on the other hand, she was very giving of things."

Pat then turned to the climate of lesbian and gay issues during the time of her rearing.

"Being born in 1954, I don't think I knew or ever heard of the words 'gay' or 'lesbian.' I always felt like an outsider, but I had no clue and, of course, I went to a Baptist college. Even in the mid-1970s, when I first came out, there was still a level of invisibility within the community. However, the women's movement fits together with the upswing of visibility for lesbian women.

"In the late '70s, the Women's Resource Center in Norman sponsored a coffeehouse once a month that featured lesbian entertainment and that was my first experience with any kind of gay community. About that time, there were a couple of bars in Oklahoma City that were primarily for women. At the old bar, D.J.'s, there was a foyer where you signed in. The foyer had a little window, and D.J. sat behind the window. She checked your I.D. and decided if you got in. If D.J. didn't like you, you didn't get in. Also, that was before it was legal to sell liquor by the drink. Part of what D.J. offered was a feeling of safety once you were inside."

I asked Pat about the current issues facing gay individuals, particularly the continued beatings and deaths perpetrated on gay men.

"For men, there are 'gay-bashers' that hang around bars. They are guys that look for somebody to beat up on. For women, there are other safety issues. Lesbian women do not

experience as much physical danger. However, if a lesbian mother was involved in a divorce, until recent legislation, she was considered an unfit mother because she was a lesbian. Therefore, she lost her children to the custody of the father. Still today, many lesbians and gays fear losing their jobs if their sexual preferences are made public.

"Today we do see more public lesbians. Thirty years ago there were a few public lesbians, such as Martina Navratilova, but her career badly suffered when she came out publicly. Then, just last year, one major women's basketball figure made a public disclosure of her lesbian lifestyle, but it did not seem to affect her career.

"Still, Oklahoma City is not an easy place to be highly visible as a lesbian. Here, invisibility is more the norm, meaning lesbian women living in the unspoken assumption that they are straight. I cannot be quietly who I am and be recognized as a lesbian woman, without making a public statement." With the latter statement, Pat and I discussed how many lesbian women make unspoken statements through their hairstyle and clothing. Pat smiled and admitted that she was kind of "out there," with her haircut that had been accomplished by the use of barber clippers.

As we concluded, Pat said, "Not being seen for who you are is traumatic. What fascinated me about Carol and Edna is that they survived so long in their oppressive environment of secrecy. It must have been like not being able to breathe."

# Margaret

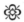

I INTERVIEWED MARGARET after her return from an extended stay in France. While there, she had brushed up on her French and visited an old friend. On entering Margaret's home, I noticed her artistic eye as displayed by her surroundings.

As we began, I settled into a comfortable rocking chair, in which I felt right at home. Since it was a lovely fall day, Margaret had her patio doors open to the air and the rustling sound of leaves. In addition, her two canine companions were vocal about their pleasure in an afternoon outside.

I asked Margaret about her family.

"My father graduated from West Point in 1928, then joined the Horse Drawn Artillery at Fort Sill, Oklahoma, where I was born 10 years later.

"My father was a very fine Army officer, bridge player, loving patriarch, and a sexist man of his times. My mother was very gentle, with a sharp wit. She was a woman of her times. Mother was indeed a lady. Everybody thought she was an angel. I thought that she had it in her to be an angel." Margaret was one of four children.

Margaret went on to share that because of her father's military career she was reared in Germany, Switzerland, and Greece. Issuing from this diverse background, Margaret worked for the Washington (D.C.) Urban League and the Civil Rights Movement. In 1966, during her stay in our nation's Capitol, Margaret met and married her husband, Gene, who was of African descent.

"When Gene and I married, it was illegal in Oklahoma and a number of Southern states. There were anti-miscegenation laws, meaning laws against interracial sex or marriage. These laws were struck down by the Supreme Court in 1967. However, after Bobby Kennedy and Martin Luther King were killed, Gene and I looked at each other and said, 'We're out of here.'"

The couple promptly moved to Spain, where their only child, Malika, was born. However, after a year in Spain, Gene and Margaret decided that the United States was home, and they returned.

Margaret and Gene were married for 17 years and have been divorced for over 20 years.

During our interview, Malika airily bopped in to pick up something and, after a brief introduction, she was on her way. During this short meeting, I observed Malika to be an interesting young woman, with an exotic appearance, which combined milk-white skin with wavy raven-black hair.

After her daughter's exit, Margaret and I discussed that, from her appearance, Malika could have been born from a

number of genetic lines, and I shared that I felt that melding together of all races is one hope for the future in dissolving racial barriers and prejudice. Of course a quicker method would be for each human being to send forth kindness, forgiveness, and love toward every other planetary walker.

I asked Margaret about her work life.

"I retired two years ago after working 21 years for a small state agency. I was born and brought up to be a woman of leisure, and now I love it."

Margaret went on to relate that she had worked with Herland for several years and, as she did so she would think, "Men are so lucky. They get to make love to women." At 54, Margaret realized she was gay.

After her epiphany, Margaret said, "I was like a baby kitten fixated on a ball of yarn. I fixated on one woman, with whom I had little in common, and we lived together for four years. I've been single for the last nine years. Being single is quite liberating."

Margaret first met Edna when Rhonda and Louise got married.

"It was a wonderful, wonderful ceremony. But, I didn't really get to know Edna until the last year-and-a-half of her life, after Rhonda moved to Denver. My friend, JoAnn, and I would pick up Edna to go to concerts and various Herland activities. But Carol was totally in the background.

"Edna was so funny and full of life. Most of the time, I took Edna to her radiation treatment for the skin cancers on her ear

and lip. I took her two or three times a week, and Carol would come out and help me get Edna in and out of the car. I also would go pick up their prescriptions. However, I was never invited inside their home. We would go through the money exchange outside. I felt that was Carol's way of protecting the 'secret' nature of their relationship. It was sad. Then Edna up and had her stroke and died. Then, I got to know Carol.

"After Edna died, many of us were worried where Carol was going to live if Edna had not left her the house. I don't think anybody knew that Carol had any money at all. Who even knew that Carol had a degree in music? Rhonda had a gorgeous piano in her home. Carol could have played it.

"Carol was once a very pretty woman, but she wasn't pretty when I knew her. She had a milk-white eye, and she didn't wear her teeth. She might have worn her teeth if her eye hadn't been bad, but Carol had given up. She was going to be comfortable.

"When I talked to Carol, I would think, what in the hell are we going to talk about, but Carol and I got started because she had a lot of seashells. My mother's favorite place was Sanibel Island, Florida, which is the third best shelling beach in the world. Carol's family lived in Florida, just minutes away from Sanibel Island. Carol tried to give me her shell collection, but I tried not to take it. [Carol won. Margaret showed me an exquisite collection of shells that Carol had given her.]

"When Carol found out that I lived in Germany, she tried to give me her Hummel collection, but I wouldn't take it. I thought maybe she had one or two Hummels, but it turns out that she had about 40.

"Carol and I would also talk about knowing whether someone was 'part of the gang.' Carol took pleasure in people being openly gay."

Not missing a beat, Margaret said, "Nobody talks to older people about sex. I had a ton of gay aunts, uncles, and cousins. When the last cousin came out, Mother said, 'This is just getting a little boring.' My father was homophobic toward male homosexuals. Mother loved the *Well of Loneliness*, and she read it when it was banned. Mother said that it was 'so sad.'

"They used to call Edna, 'Ed.' Before they got together, Edna would go out to clubs. Edna was the one in danger of getting arrested for dressing in men's clothes. It was a rule that if you were going out to a gay club that you had to be in at least one article of female clothing. It was a law on the books.

"Even though they never did, Carol and Edna both were delighted to see Louise and Rhonda being openly gay. Maybe it relieved their disdain for themselves. Carol definitely thought that there was something very wrong with it. Carol's father told her that she catered too much to Edna, and Carol shut down in fear that her father would accuse them of being queer. Carol was terrified that her neighbor, Judy, or Edna's sister, Dot, would know, and she was always waiting to be

confronted.  She lived in terror that someone would say, 'Are you queer?'"

As Carol's story has unfolded, it was not until the last two months of her life that she gushed forth decades worth of unspoken and suppressed thoughts and feelings.  Carol lived in the prison of her fear but, from the pain of Edna's death and possibly from knowing that her own death was imminent, Carol's walls gave way, and she was free at last.  Now safely on the other side, no one can ask her, "Are you queer?"

# Barbara

BECAUSE BARBARA LIVES IN OREGON, I interviewed her by telephone. Barbara was born in 1932 and met Carol in 1952, while they both were in the Marine Corps and stationed in Washington, D.C.

Barbara began by telling me that she was in the Marines for three years, during the Korean crisis, from 1951 to 1954. Barbara said that she enlisted, at 19, for the adventure and to get away from her home in Alameda, California.

She went on to say that while she was in the Marines, she lived in a barracks that contained 200 women, and she and Carol were assigned to be "bunkmates."

I asked her to describe their accommodations.

"Our cubicle contained two twin beds, and the walls did not go all the way to the ceiling. The barracks contained a large bathroom with a whole row of basins and, unlike the lack of privacy in high school, the bathroom had divided showers with curtains.

"In the Marines, I worked as an accountant, which was my profession throughout my life. I'm not sure what Carol's work

was but, a few months after we met, she was assigned to Camp Lejeune in North Carolina.

"However, the Marines didn't really suit Carol, and she was only in for two years, even though the regular tour was three years."

At this point, I shared with Barbara that in my research to understand the social climate in which Carol and Edna had been reared and had lived their earlier years, I discovered, during the McCarthy era of the 1950s and its witchhunt to rout out and rid our nation of "communists," gay men and lesbians were under similar attack. During this period, psychiatrists and society at large considered homosexuality to be a "perversion" and homosexuals to be "psychopaths."10

Furthermore, during McCarthyism's governmental exorcism, same-sex love was considered "criminal," and it was not uncommon for a woman to be summarily discharged from the military or other governmental posts on the grounds of being a "lesbian," without the benefit of a hearing or even the knowledge of her accuser or the evidence on which the discharge was based.11

I asked Barbara if Carol was discharged early because she was a lesbian.

"I don't remember how Carol got out early, but it could not have been because she was gay, because she had an honorable discharge and went to school on the G.I. Bill.

"When Carol got out of the Marine Corps, she came back to Washington, D.C., and, when I was discharged in 1954, Carol and I moved to San Jose, California. I went to college, and she went to 'Beauty School.' Carol already had her music degree when she entered the Marines, but she never used it."

I then asked Barbara if she and Carol were partners, and she said, "Yes."

In describing Carol, Barbara said, "Carol was very quiet, not real social, and very introverted, but she was a very nice person.

"However, in the summer of 1956, Carol and I parted ways, and I left San Jose and moved to Pacific Grove and, in 1974, I moved to Oregon. After that, I lost touch with Carol and never saw her again, even though we did send Christmas cards."

I next asked Barbara what information she received about homosexuality during her youth, in the 1930s and '40s.

"I never heard of such things."

I shared that in my reading I found that in the 1920s, '30s, and '40s there was a fairly active subculture of gay men and lesbians in areas of sophistication such as San Francisco, Chicago, Boston, Harlem, and Greenwich Village.[12]

Barbara retorted, "If there was a subculture, it wasn't anything I knew about." Barbara went on to share that she discovered her lesbianism in the Marine Corps.

Next, I asked Barbara if she was aware of the attempts in the 1950s to rid the military of gay men and lesbians.

"The older gals would tell us about it. They told us to watch who we talked to. In the service, the unwritten rules were: 'Don't ask. Don't tell.' When you did that, nobody would bother you. No one I knew was dishonorably discharged, but there were plenty of people that could have been."

Regarding her sexual preference, I asked Barbara if she had any fear or paranoia of being found out while she was in the Marines.

"I was probably too dumb to be scared. I was very naïve when I went into the Marine Corps. I had never been away from home. Where I was stationed, most of us were not aware of what was going on in the world. We had little access to newspapers, and television was in its infancy. Later, when I was in college, I was too busy studying to pay attention. Besides, the government managed the news and what they wanted us to hear. We are just now learning what went on during that period."

Through the 1960s, '70s, and '80s, Barbara had a long-term female partner. I asked her how it was to live during this period as a gay woman.

"We [Barbara and her partner] led a double life. We had few friends. I didn't like it. Now, gay couples are very open, because society allows them to be."

Barbara went on to share that some of the people in the community of Salem with which she and her partner of 11 years, Pat, associate are very open and accepting and, because of the social climate in Salem, she and Pat had recently married.

Pat and Barbara could have their ceremony, but they couldn't file their marriage with the state of Oregon.

Even with that limitation, I could hear the contentment in Barbara's voice that finally, after all those years of leading a double life, she and Pat could live "fairly" safely and openly.

# Lives Lived in Secret

**THROUGHOUT MY HISTORY GATHERING** on the lives
of Carol and Edna and especially after my conversation with
Barbara, I wondered about the types of messages Carol and
Edna incorporated into their psyches during their developmen-
tal years and young adulthood.

Edna was born in 1913 and lived during the time of the
emergence of small, sophisticated subcultures of homosexu-
als within large metropolitan areas, but Edna had only an
eighth-grade education and was reared in rural Oklahoma.
I wonder if she had the words "lesbian" or "homosexual" to
identify her sexual thoughts or feelings? However, as I study
the photographs of Edna taken during the 1930s, I see a
young woman, with bravado, in many saucy poses, including
the one, during Prohibition, in which she defiantly drank an
unlabeled bottle of beer. From her appearance and knowing
that she was a voracious reader, I do not want to underesti-
mate Edna's fund of knowledge about her sexual preference
and its meaning within the social context of the time in
which she lived.

Turning to the photographs of Carol, I see a little girl in her affected dance poses and costumes. In her adulthood, I see a constrained woman, who was reared in an affluent, upper-middle class family in Chicago, during the 1930s and '40s. From her history, I know that keeping up the appearance of heterosexuality was extremely important to Carol. I can only imagine the social messages, regarding homosexuality, that Carol internalized during her youth and the emotional torment that she endured from the knowledge that she was a lesbian. In the 1930s, the prevailing view of society and the medical profession was that lesbians were decadent, pathetic monstrosities and, in the 1940s following World War II, wives and mothers were considered the only "normal" roles for women. This was followed by the 1950s institutionalized insanity that caused many lesbians to live secret lives filled with guilt, pain, and self-hatred due to the "hideous stereotypes" of lesbianism. It has been said that the 1950s were the worst time in history for women who loved women.[13]

The 1960s and the years that followed turned the rigidity of the 1950s on its head, but for older lesbians, such as Carol and Edna, who had spent their adulthood leading double lives, it was difficult for them to conceive of publicly disclosing their true identities.[14]

Although the time periods differ somewhat, the following information derived from an interview with May, about her relationship with Virgie, could have been taken from a conversation with Carol or Edna.

May says she met her lover at the University of Texas in the 1920s, and though they stayed together for more than 20 years, they told almost no one about the nature of their relationship. It placed such a strain on them that May often thought of leaving Virgie, especially during the 1930s, because "I was tired of hiding in a corner. And there was no question of coming out. I wanted so much to be able to talk freely with people, to be like everyone else, not to feel like we loved in a wasteland, but that was impossible ... I knew how people would look down on us if they'd guessed."[15]

May stated that it wasn't until the 1950s that she became aware of other lesbians in the world, and it wasn't until the feminist movement in the 1970s, when she was in her late 60s, that she felt that she could talk about her years with Virgie.[16]

Unlike May and Virgie, Carol and Edna, during their years together, had their small group of lesbian friends in which they shared their identities as lesbian women but, as their friends died or moved away, Carol and Edna became more and more isolated, and I suspect their relationship suffered for their lack of community and their claustrophobic lifestyle, which was so vividly depicted by the atmosphere of their home at the time of their deaths.

However, despite Carol's prim and proper attempts to "keep up appearances," the bravado of Edna's youth held her in good

stead, because what Edna could not publicly say she shouted with her clothes, as she transitioned from the feminine attire of her youth into men's attire as she grew older.

Finally, in the later years of her life, with the help of Rhonda and Tamara, Edna was able to participate in Oklahoma City's lesbian community, and she jumped in like a duck to water. But, for whatever reasons, Carol held back in what appeared to be isolated torment. It seems that only after Edna's death and two months before her own death did Carol's walls crumble, and she spilled forth unspoken thoughts and feelings, even to the point of wanting to record her story.

But alas, Carol hesitated. Only when she was safely on the other side, could Carol give permission to me as I lovingly resurrected her flowerbeds. At that time and throughout the

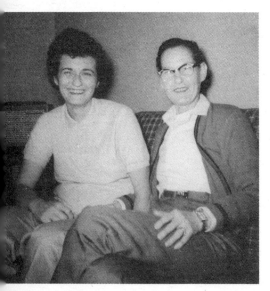

writing of this manuscript, I have felt that I was not only given permission but requested by Carol's and Edna's spirits to put their story on paper, and I hope that they are pleased and at peace with these pages.

**Carol and Edna—**
**Behind Closed Doors.**

**Carol and Edna—On Vacation.**

As I conclude my review of the photographic lives of Carol and Edna, I see only hints of their affection as they hold hands, or Edna hugs Carol from behind, and even places her cheek on Carol's. But I notice that all of these photographs are taken within the confines of their home or on vacation and away from the prying eyes of neighbors.

What a loss for Carol and Edna and their family and friends that they lived their love in secret. However, I remember that Archie, Dot, Judy, Jan, and Velma never said that Carol and Edna were "just friends." I sense from their descriptions

**Carol and Edna—Away From Prying Eyes.**

of Carol and Edna's relationship that they all knew its true nature, but these close friends and family members were reared in a time when the most important truths were implied or left unspoken. So, actually Carol and Edna did not live their life and love in secret. They just thought they did.

# Epilogue: Reborn

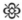

It has been a year since I began this writing. During that time, Carol and Edna's home and gardens have been reborn.

In rebirthing their home, I strove to be energy efficient and environmentally friendly. The windows were replaced. The dark draperies have given way to light and airy sheers. The walls, ceilings, and floors are now well insulated.

The previously dark-wood paneling on the walls and ceiling have been replaced with sheetrock and coated with VOC-free paint. After removing the very tired carpets, the underlying oak floors were restored to their former beauty. The kitchen and bathroom are brand spanking new, and the house is sporting new innards, such as plumbing, electrical wiring, an on-demand, electric, hot-water heater, and heat-and-air conditioning systems. In addition, each room has a ceiling fan, which I use as much as possible in lieu of artificial cooling. The house proudly wears new shingles, and white siding completes Her transformation.

Last summer, I unearthed Carol's gardens and each precious rock and bulb. Each rock was given a new resting place to

be viewed in all its splendor.  After a winter's nap, the bulbs sprouted this spring, and the flowerbeds were array with lilies of every color and description, and five new saplings made the yard their residence.  As any gardener knows, gardens are always in transition, and I am frequently found there continuing my "dirt therapy."  Wearing a big straw hat, a long-sleeve shirt, and rubber gloves, I'm out there with my knees and elbows down and my back-side up, as I weed, plant, replant, and reconfigure the pre-existing flowerbeds and dig new ones.  In my enthusiastic gardening, every rock's resting place is subject to change.  In other words, I am having the time of my life birthing and rebirthing Carol and Edna's yard and gardens.

I love my cozy new home that weighs in at about 900 square feet.  I especially enjoy the fact that I can leave my front door and walk three-to five blocks and arrive at two grocery stores, seven eating establishments, a movie rental store, a copy center, and a hardware store, the latter of which also carries plants and gardening supplies.  On my walks, I like to carry a plastic bag and pick up trash and cans and bottles for recycling.  I am told that we each must be the change that we want to see in the world.

In this last year, new faces have appeared on the block. Lori and Lisa sold their home, and it is now occupied by three pleasant young ladies, two of which walk to their classes at the nearby law school.  John, who is a very nice, young geologist of Cuban descent, moved to Oklahoma from Florida and lives

next door in Ralph's rental home that was formerly occupied by Hollie.

Judy is still with us and has been on dialysis for four months, and she sounds in good spirits.

Erma died this spring. I will miss the opportunity to know her better. Her nephew, Mike, is a school principal, and he and his son care for Erma's yard. Mike is planning to restore the home in which his grandparents lived and in which his father was reared. He would like one of his children to live there, but time will tell who will reside in the house on the corner in the shade of the towering pecan trees.

Because of a tumor, Ralph had a kidney removed last month. His recuperation is coming along. I worry about his spirits. But Ralph has a strong faith in God, and I know he will bounce back.

Tamara sold her veterinary practice, and she and her family are spending a year in France, where Tim is doing research on a book he is writing.

Nancy lives in Judy's mother's former home, and her front yard looks as beautiful as ever, and George still has his jungle, and I regularly plumb his mind for gardening tips.

My daughter, Sarah, her husband, Luz, and my grandchildren, Carlos (8), Leticia (4), and Azriela (2) live down the street in my former home, and we have a new addition, my 2-month-old grandson, Zavdiel. Certainly in my golden years, my grandchildren are my greatest blessing.

Also this year, my car drowned in a parking lot during an Oklahoma toad-strangling rainstorm that resulted in a flash flood. A new hybrid version has taken its place, but I am still in line for the appearance of a reasonably priced electric model.

As we all know, life is a sacred and continual cycle of birth, death, and rebirth. I haven't felt Carol and Edna's presence for some time. I feel that they have gone on and are at peace with the rebirth of their former residence. I now occupy Carol and Edna's living room and look out their front door. I feel deeply blessed to live here and tend the gardens, and I know full well that when my time comes to cross over, another person will take my place. For, we own nothing, we are only allowed its use for a time.

# Notes

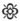

1. *New York Times.*

2. Ibid.

3. Ibid.

4. Moses, 140; *New York Times.*

5. Otto Kallir, 8; *New York Times.*

6. Peterson, 15.

7. Ibid., 16-17.

8. Ibid., 17.

9. Ibid., 15.

10. D'Emilio, 68; Faderman, 132-133, 136.

11. D'Emilio, 63-65; Faderman, 150-151, 155.

12. Faderman, 67, 106, 126.

13. D'Emilio, 68; Faderman, 100, 157.

14. Faderman, 156-157, 201.

15. Ibid., 110.

16. Ibid.

# Bibliography

"Grandma Moses Is Dead at 101; Primitive Artist 'Just Wore Out.'" *New York Times*, December 14, 1961.

D'Emilio, John. *Making Trouble; Essays on Gay History, Politics, and the University.* Routledge, New York, 1992.

Faderman, Lillian. *Odd Girls and Twilight Lovers; A History of Lesbian Life in Twentieth-Century America.* Penguin, New York, 1991.

Kallir, Jane. *Grandma Moses, the Artist Behind the Myth.* Clarkson N. Potter, Inc., New York, 1982.

Kallir, Otto. *Grandma Moses.* Harry N. Abrams, Inc., New York, 1975.

Moses, Anna Mary. *Grandma Moses, My Life's History.* Harper and Brothers, Publishers, New York, 1952.

Peterson, Victoria. *Breathless, Stories from a Survivor's Life.* Katydid Publishing, Muncie, Indiana, 2002.